A HEART SET FREE

My Story for His Glory

CREATION HOUSE PRESS

Donna St. Rock

A Heart Set Free
by Donna St. Rock
Published by Creation House Press
A part of Strang Communications Company
600 Rinehart Road
Lake Mary, Florida 32746
www.creationhouse.com

This book or parts thereof may not be reproduced in any form, stored in a retrieval system or transmitted in any form by any means—electronic, mechanical, photocopy, recording or otherwise—without prior written permission of the publisher, except as provided by United States copyright law.

Unless otherwise noted, Scripture quotations are from the King James version of the Bible.
Used by permission.

Scripture quotations marked NKJV are from the New King James Version of the Bible. Copyright © 1979, 1980, 1982 by Thomas Nelson Inc., publishers.
Used by permission.

Cover design by Rachel Campbell
Interior design by David Bilby

Copyright © 2002 by Donna St. Rock
All rights reserved.

Library of Congress Control Number: 2002112469
International Standard Book Number: 0-88419-962-2

02 03 04 05 87654321
Printed in the United States of America

Dedication

*T*his book is dedicated to hurting women everywhere. May you find God, and embrace the process as He brings you into wholeness.

Author's Note

Neither shall they defile themselves any more with their idols, nor with their detestable things, nor with any of their transgressions: but I will save them out of all their dwelling-places, wherein they have sinned, and will cleanse them: so shall they be my people, and I will be their God.

—Ezekiel 37:23

In the spring of 1996, I received a prophetic word while visiting a small church with friends. The word said: "Write the book! Write the book! Write it chronologically. They need to hear it! They need to hear it!"

I was more than two years into the writing of this book when the Lord reminded me of the word that was given that night. This is that book. It has been a painful yet somewhat eye-opening experience taking this journey. Some chapters were so painful to recall that I would have to stop and remind myself of the reality that I live in today. At other times I was moved with great compassion for the main character. Although it was myself, I felt so unrelated to the experiences. How do you tell a story about a person whose experiences are so far removed from present

reality? How do you convey incidents that one feels so completely detached from? I know what it is to truly overcome Satan "by the blood of the Lamb and by the word of [my] testimony" (Rev. 12:11).

It is only through the redemptive power of the blood of Jesus that a life once filled with unbearable circumstances and events could be transformed into one with meaning and purpose. Such is this story. It is my story for His glory.

Contents

Foreword ix
Introduction xi
Chapter One: My Genesis 1
Chapter Two: Gomer,
 Rahab and Me 13
Chapter Three: My Exodus 23
Chapter Four: New-Age Deception 31
Chapter Five: The Journey Begins 37
Chapter Six: A Way of Escape 47
Chapter Seven: Miracle on
 Rainbow Road 57
Chapter Eight: Precious
 New Beginnings 63
Chapter Nine: A Beginning
 As Well As an End 77
Chapter Ten: Perfect Will,
 Permissive Will or Perdition 83
Chapter Eleven: Purity,
 Purging and Empowerment 93
Chapter Twelve: Journey
 Into Wholeness 107

Foreword

This book tells the story of a life destined for destruction. Only a miracle could save Donna St. Rock. As the details unfold, you will be shocked, saddened and ultimately thrilled with this account of God's redeeming grace. It has been my privilege to observe the restoration process in Donna's life. Her enthusiasm and personal insight give godly principles that will help anyone who needs to be restored.

As a pastor, I look for effective tools that will help people. This book is one such tool. It seems that we have been better at delivering people than keeping them free. Donna has used these principles as she has ministered to many people in distress. I hope you will allow the contents of this book to change your life.

<div align="right">

Pastor Shirley Arnold
Tree of Life Family Church
Lakeland, Florida

</div>

Introduction

"Michael Roderick is dead! Michael Roderick is dead! He's dead," shouted the detective as he stood in the doorway of the room where my cousin and I were being held in the all-too-familiar local police station. "We know who did it! We know who it was!" he continued to shout. Two familiar names rolled off my lips without hesitation, confirming the detective's suspicions.

Only a few hours earlier my cousin Marie and I had picked up my boyfriend, Michael, at his home. We were headed for an evening shopping spree with stolen credit cards. We were not far from the house when we realized that we had forgotten the cards. Marie turned around the light-blue Ford station wagon that she had borrowed from our uncle, and we headed back. As we pulled up in front of the house, another car pulled up beside us. The person who was driving and the one riding in the passenger seat were familiar to us. Michael got out of the car and exchanged a few words with the man who would, in a few minutes, be responsible for his murder. This well-known hoodlum was fresh out of prison for a previous murder and he had kept his pursuit of Michael no secret. To this day I do not know why Michael lost his life that night. I do know, however, that this man acted on behalf of another who ranked high on the underworld totem pole.

That night was not the first time that Michael and I had been shot at. A few weeks earlier, shots were fired at us as we passed through an area well known by the police for its underworld activity. But this night would prove to be different. In a moment's time shots rang out, hitting Michael four times in the chest. The remaining bullets were fired at my cousin and me, missing us and hitting the door on the driver's side of the station wagon.

I remember getting out of the car. I knelt down on the ground beside Michael, spoke a pet name to him and kissed him as he lay there. I didn't know at the time that it was a kiss good-bye.

I remember being put in a police vehicle and being taken to the local police station in a city known nationally for it's underworld activity. As my cousin and I entered a large room in the local police station, we saw a barrage of detectives, most of whom I knew (or shall I say, knew me). Some were state police officers and others looked to be FBI agents. One of them reminded me of a college professor. He removed the pipe he was smoking from his lips and asked, "How old are you now, Donna?"

"Nineteen," I replied.

I had the impression he had been watching my life over the past few years, keeping track of me as a result of my involvement with the underworld. Officers questioned my cousin and me separately for what seemed like hours, and then placed us in a small room for what seemed like an eternity. I was still in such shock that I don't remember wondering

INTRODUCTION

whether Michael was dead or alive.

Suddenly the detective burst in, shouting the news of Michael's death. Calmly I identified his killers.

Later that night I was released to my parents. During the thirty-minute drive home, I laid in the back seat with my head in my mother's lap, sobbing. Words could not capture the depth of my emotional grief that night; however, I remember thinking, *It's finally over, it's finally over*—the drugs, the pornography, the beatings...everything that my five-year relationship with Michael had exposed me to. In John 19:30 Jesus cries out, "It is finished," and bows His head. The Hebrew word for "finish" here is *teleo* (tel-eh-o); it means "to end, to complete," and "to bring to a close."

That cold October night in 1969, Michael Roderick died at the age of twenty-six for no reason and without any hope. His short time on earth was ended, and he would no longer affect anything or anybody. Jesus died unacknowledged, rejected and accepted by only a few; however, His life was given with the assurance that many would be touched, changed and eternally restored to the Heavenly Father.

When Michael died, a part of me died; a part that for many years would remain in the dirt and darkness of life. The seed of my life's situations and circumstances had to rot in an underground world of darkness until I allowed my life to be touched by the Master. His touch turned my life around and propelled me in a totally new direction in my journey— all for His glory!

Chapter 1

My Genesis

In the beginning God created the heaven and the earth. And the earth was without form, and void; and darkness was upon the face of the deep. And the spirit of God moved upon the face of the waters. And God said, Let there be light: and there was light.

—Genesis 1:1–3

The beginning of my life was much like this passage from the first chapter of Genesis—it would be thirty years before I would allow God to move over my life. Only after much pain and suffering would I allow the Master to speak light into my life, and the true light would come. I don't remember when or how my rebellion started; I just know that once it did, it was as unstoppable as a hurricane. My mother was emotionally ill for most of my childhood. As I began to look back over those years in remembrance, I penned the following words:

I Remember

I remember pretending to be sick so I could sit in the living room and watch TV eating tomato soup with bread and butter just to be home with you alone;

I remember visiting you on holidays and weekends as you waved from an institution window behind huge walls;

I remember burned mattresses, empty wine bottles and prescriptions of sleeping pills, and your continuous cry that you were going to scream and never stop;

I remember long periods of time at relatives crying out for you and not understanding the unfairness that I felt;

I remember as you lay on the couch days upon end, and I remember the time that I sat down by you and you took your nails and ran them down one side of my face, not understanding the feeling that I felt coming from one who was to love me;

I remember my dad cooking, yelling and sometimes crying out of pure frustration;

I remember many, many periods alone with just he and I and my sister, trying to make sense of all this;

My Genesis

I remember a desire to be loved, nurtured, and understood only to find abandonment, a struggle for self-preservation and confusion;

I remember the smell of White Shoulders perfume, and a white dress that you wore that had one bare shoulder;

I remember beautiful black curly hair and dark skin, and the time when you were thirty-six at your brother's wedding and burned your beautiful baby-blue chiffon dress with a cigarette that you were hiding from your father;

I remember big flat hats, white gloves and pastel cotton dresses that had to be starched and ironed the night before church;

I remember feeling like my needs didn't matter, that yours were more important, and I remember reaching outside my home for fulfillment very early in uncharted waters;

I remember detachment, rebellion and a feeling of total exposure knowing this was not the way it should be;

I remember anger, resentment and total misunderstanding and escaping through drugs, alcohol and sex addiction;

I remember police stations, prisons and motel rooms; guns, secrets and violence;

> *I remember running and running and running;*
>
> *I remember abusive relationships, unfulfilled dreams and a tremendous sense of no self-worth;*
>
> *I remember a desire to be right and balanced and loved for who I really was on the inside;*
>
> *I remember reaching out many, many times and coming up empty;*
>
> *I remember having an ideal about love but never experiencing it;*
>
> *I remember trying through various avenues to fill a void in me that nothing and no one had come close to recognizing, let alone relieving the pain that I felt.*

Early in my childhood I embraced reaching out as a survival technique. We were children and we needed our mother; but my mother's needs were greater, so my sister and I adopted role reversal. We became responsible for my mother—my sister more so than myself. I detached early, and she stayed and became my mother's caretaker and emotional container.

As a result of my circumstances, when most children were secure at home sitting in front of the television with their families—as was the environment of the early sixties—I was out in a world that consumed me physically, emotionally and spiritually. I was

My Genesis

introduced to my sexuality at the age of ten by an older girl in our neighborhood and became sexually active at age thirteen. My stolen childhood and premature introduction to sex would become the very core of my self-identity for many, many years to come. However, it would also become the platform and driving force deep within me to help others.

My life became a paradox within one year. At the age of twelve, I wanted to go to Catholic school and be a nun, and at age thirteen I was arrested for the first time. I believe my early recognition of the call of God on my life, and an intense hunger to serve Him, caused the enemy to work double-time against me. My exposure to the world and its appetites happened very quickly and thoroughly. When I was first summoned to court to answer charges, I was barely a teenager—not very young by today's standards, but certainly so in the early sixties. The judge told my parents that I was too young to be charged, so they let me go. Unfortunately, it wasn't the last time I saw the inside of a courtroom. But, since most of the men that I knew during this time had connections in the right places—on one side of the law or the other—although I spent many an overnight in jail, I never was sentenced and never served time.

I was nineteen when Michael was murdered, one week after his twenty-sixth birthday. Was it the end, or just the beginning for me? My life had been in overdrive since age thirteen. For several weeks after Michael's death I wore out Stevie Wonder's then-popular song, "Yester-you, Yester-me, Yester-day."

Michael's "friends" were calling to check on me...so they said. Soon they exhibited what was really in their hearts, and I found out that there was "no honor among thieves."

My cousin and I were the state's key witnesses in Michael's murder trial—a trial that would involve some very well known people from the underworld. We had witnessed the murder and had named those who were responsible. Various city and state police detectives called my parent's home repeatedly. These men were well acquainted with the corrupt strategies and capabilities of the people responsible for Michael's murder, and I knew from previous situations that I had witnessed that the police were apprehensive about whether I would make it into court alive.

Meanwhile, my life continued to revolve around the world that Michael had introduced me to. Michael's home, and most of its contents, was seized by the police. One whole room in the house—like a library—was dedicated to pornography. I was well acquainted with that room. It was Michael's private sanctuary. We had spent endless hours making use of its resources. Michael watched over that room as if he was its librarian, carefully making sure all items were present and accounted for. The police asked me several questions about that room, as well as other items that were in the house.

In the days ahead I had several conversations with men who were connected to the underworld. These conversations centered on my well being and survival. Some of these men I later had relationships

with. Three of them died: one of a self-inflicted bullet wound while playing Russian Roulette under the influence of drugs; another was found in the trunk of his car, strangled with a piece of wire; and another was gunned down with a sawed-off shotgun as he answered his front door. Their deaths were not connected to me; but they were the result of a lifestyle that I had become comfortable with—a lifestyle that respected no one, where power was your ticket and death your expected final ride. No one appeared to fear anything or anybody, least of all God.

I was reminded daily that my life was in danger, and was warned time and time again that I must be very careful. Later I found out that one of the people warning me was connected to a relative of the man who drove the car that night Michael was killed. The driver was also being charged with the murder. Within a year, this relative, through a mutual acquaintance, offered me ten thousand dollars to retract my statement to the police and say I was on LSD the night that Michael was murdered. I never considered it for even one moment.

I loved Michael more that anything in my life. As a result of my home situation, I had easily attached myself to him and his world. I met Michael when I was only fourteen. I was at a local amusement park one night, sitting in a car with a group of friends, when he poked his head inside. He was twenty-one and had a black eye and other bruises on his face from a recent fight. There was an instant attraction—an undeniable chemistry—between us. That was the

beginning. Little did I know the tragedy and heartache that this relationship would cause in my life—not only the trauma of witnessing his murder, but also what I would be exposed to at such a young and vulnerable age.

By age thirteen I had already developed a major attitude toward authority. I did what I wanted, when I wanted, regardless of the consequences. The lifestyle that I was exposed to as a result of my relationship with Michael was my ticket to everything. The foundation of my training was drugs, sex and the combined experiences that this lifestyle had to offer. These ingredients became the very substance through which I would become a survivor, in the strongest sense of the word. Since Michael was seven years older, he was well educated in the things of the world. I was trained for his pleasure. I was like a piece of fresh, moist clay in his experienced hands. Many of the things that I was exposed to and wrongly educated in have taken me years to overcome. They have been the spiritual and deep psychological roots of many struggles that I have had to experience and grow through in my life. However, through the valley of those experiences, I have learned how to exercise power over and discernment in those areas. I have overcome that I might be used to help others overcome.

Thank God that our issues, once acknowledged and overcome, can be used to help others. God does not waste our tears, time or torment. No, He has a greater plan and promises that, "as He comforts us, we will be able to comfort those who are in any trouble, with the

same comfort with which we ourselves have been comforted by God" (2 Cor. 1:4, paraphrased). God confirmed this to me many years later as He began a healing process in this area of my life. The Holy Spirit spoke to me in a meeting one night and said, "I am touching every area in your life that was violated as a young child. Yes, I am touching those areas with my purity. Have you not felt the Refiner's fire? I am bringing purity and holiness to those areas that you, too, will walk as an assayer among My people. Yes, as one who tests the refinement of gold, you will challenge the purity of My people and help to bring about that change." (See Jeremiah 6:27, NKJV.) My healing has come through yielding and allowing God to touch those areas that have been hidden and in need of repair.

I became pregnant by Michael at age sixteen and, observing the response of other young girls who had become pregnant by their boyfriends, I decided to abort the baby. It was a very uneducated decision, but I had no mentor except the street. There was no one with wise counsel in my current circle of friends. So I let Michael make the arrangements for this then-illegal procedure.

I remember that day well. I can still see the abortionist standing over a stove in the kitchen of Michael's apartment, shaving a bar of soap into a pan of hot water. I remember the long rubber tube. I do not remember any sensation, just numbed emotions. After the procedure was completed, I went home to my parents' house. When the cramping began, I

arranged to go to my aunt's. She didn't know what was going on, but her home was always one of love and safety for me. As the cramping grew more and more intense, I phoned a friend who gave me a ride back to Michael's. I remember literally dragging myself up stair after stair in tremendous pain, and finally reaching the door to his third-floor apartment. When I got inside, I couldn't wake Michael. He had been up for several days on amphetamines and had passed out from sleep deprivation. I had seen him this way many times before and knew that he might not wake up for days. I lay by him on the bed and, for the next several hours, endured pain that was almost unbearable. This experience haunted me for years until I found peace and forgiveness through God's love. Thank God for His Blood. I love you, Sarah, and I am sorry.

Michael's death devastated me. I spent several years searching for answers in all the wrong places. Soon after his death I began making trips to the public library, reading everything that I could get my hands on, no matter how far-fetched or how outside the norm of my religious upbringing. I wanted to know where Michael went and what his options were. Unsatisfied by my Catholic teaching and the many mixed messages that I had received in my early childhood, I let Satan bait my appetite for the occult. My hunger for answers drove me to investigate astrology, reincarnation and numerous aspects of the occult and New-Age belief systems. No avenue went unexplored by me over the next few years, from sleeping under a pyramid to involvement with a

New-Age breathing process called "Rebirthing," where you were supposed to experience all the things that got you to your present state of mind. (You never had an experience that freed you, just an experience of what it was.) My journey into the occult and New Age started me on years of involvement with psychics, astrologers and the like.

Eventually I found that each new road, each new hope, only brought me to a dead end. At the end of each quest for truth, my pain and unanswered questions were still there waiting for me.

Chapter 2

Gomer, Rahab and Me

For their mother hath played the harlot: she that conceived them hath done shamefully: for she said, I will go after my lovers, that give me my bread and my water, my wool and my flax, mine oil and my drink. Therefore, behold, I will hedge up thy way with thorns, and make a wall, that she shall not find her paths. And she shall follow after her lovers, but she shall not overtake them; and she shall seek them, but shall not find them: then shall she say, I will go and return to my first husband; for then was it better with me than now.
—Hosea 2:5–7

Gomer was the unfaithful wife of the prophet Hosea, and Hosea's relationship with her was symbolic of God's relationship with rebellious Israel. Her name comes from the Hebrew word *gamar* (gaw-mar), which means "to come to an end." In my quest for truth, along with a deep-seated desire to know Him at a young age, I became like Gomer. I was unfaithful; looking for love in all the

wrong places. Not only was I unfaithful to God, but also to most others I had relationships with. Someone always had better wool or flax.

Rahab, on the other hand, was a harlot in Jericho who helped the spies to escape. Because of this, she and her family were spared from the destruction of Jericho:

> Behold, when we come into the land, thou shalt bind this line of scarlet thread in the window which thou didst let us down by: and thou shalt bring thy father, and thy mother, and thy brethren, and all thy father's household, home unto thee. And it shall be, that whosoever shall go out of the doors of thy house into the street, his blood shall be upon his head, and we will be guiltless: and whosoever shall be with thee in the house, his blood shall be on our head, if any hand be upon him.
> —JOSHUA 2:18-19

Rahab later married an ancestor of David and became part of the lineage of Jesus Christ. She was commended for her faith in the book of James. (See chapter 2, verse 25.)

Unlike Gomer, Rahab understood the workings of God. She had heard the testimonies of the Red Sea and how Moses had led the Israelites out of the bondage of Egypt. Throughout my childhood, I remember having reverence for God—to the point that, when my sister and I went to bed, if we burped we would say, "Excuse me, Jesus!" I loved people and

wanted badly to be loved. Many years later I would sit in recovery groups as part of my training and, as I looked around the room, I would thank God that I had teeth and a place to live. I would feel grateful that He had spared me in so many ways compared to others. It was the scarlet cord of His blood. In some ways I was operating according to God's principles without ever acknowledging their existence. In some ways I didn't reap what I had sown...perhaps because of the gifts and callings that He had placed within me as a child. Maybe the hunger that I had for Him at an early age was in some way working on my behalf and for my good.

Meanwhile, the newspapers told the story, at times on the front page: "Suspect Held in Gang Slaying" and "Gang Feud Seen as Slaying Cause," and so on and so on. I lived in crippling fear for my life and the lives of my family members. To escape, I began to spend time on weekends with a friend who lived in Boston. Relationships with men were troublesome and painful because my life had been so wrapped up in Michael. This friend was gay, and her lifestyle seemed like a safe haven for the time being. There was certainly no fear in being out and about in gay bars—no one knew me there, unlike the bars in my hometown. This was my first real introduction to a lifestyle that I had seen and read about in plenty of Michael's pornographic materials. He would encourage me, and now I found myself comfortable and very receptive to this new lifestyle. Boston became my hiding place and the gay lifestyle my comfort zone.

Back home, the tension was growing. The need to give my family some type of relief became more and more evident. Fear hung over their home like a weighty black cloud about to burst forth, and the effect of it overshadowed every area of our lives. One day my parents received a call from the detective who was handling the case. He said the department feared for my life, and I must leave town. It was decided that I would be sent to Florida to stay with a friend I had grown up with. Satan was again placing me where my sexual roots had begun.

Ann was much older than I and was now married. The day that I arrived in Florida she was coming home from the hospital with a new baby. This family setting felt very strange and was the last place I wanted to be. I soon made the connections that I needed: I moved in with a biker that I had met and secured a job at a well-known beachfront hotel as a manicurist.

Harry was a displaced Hell's Angel from California and told some amazingly wild stories. It was a short-lived relationship at best. After several months I made my way to Miami, where I ran into some people from back home. These men were not connected to the people who murdered Michael, but they were in the same circle of influence. I began to feel the same fear that I was experiencing back home.

One day I received a message from the police in my hometown that I must return there; I was to be the state's main witness for a hearing before the murder trial.

Nothing had changed at home. It appeared that

Michael's friends were on a waiting list for me. They wined and dined me. It was then that I decided home was not where I wanted to be. I contacted my friend in Boston and went there. Soon, however, the police from my hometown showed up at my apartment. Several detectives walked in and looked around. One of them picked up a satanic bible that was on the mantle of the fireplace and, with little apparent concern, asked why I had not contacted them as to my whereabouts. The hearing to select the jury for Michael's murder trial was about to begin. I assured him that I would be there.

I didn't return until after the hearing, however. When I did show up, the papers again told the story: "Girl Witness to Killing 'Alive and Well.'" They postponed the hearing as a result of my absence.

Shortly after returning home, I was again contacted by the mutual friend who was acting on behalf of the relative of one of the men charged for Michael's murder. The contact offered me money to leave town while the trial took place. At the time this seemed wise, so I accepted. (This was the man who was later found dead in the trunk of his car.) Arrangements were made, and I was soon on my way to a hotel in New York City where I stayed for six weeks. This time the papers said, "Woman, Slaying Witness, Disappears Before Trial." Foul play was suspected, and the police in several states, as well as the FBI, were seeking me. Meanwhile, my cousin, who had also witnessed the murder, was being held under heavy police guard until the trial.

I had become well acquainted with moving by this time, so I quickly adjusted to my new surroundings in New York City. I had time, no agenda...and plenty of money was delivered to me periodically. Some of the couriers were tolerable, while I could not wait for others to give me the money and leave. Some made the drive to New York in anticipation of being in the company of a young girl alone in a hotel room. Their fantasies were shattered when they found out that I was not as responsive as they had envisioned on their long drive.

Six weeks later the hearing was over, and I returned home. This time I decided that Boston would be my permanent home. I contacted my friend Mary and finalized things. Aside from being a lesbian, Mary was also a prostitute and sold cocaine. She was the oldest of twelve children and had been molested by her father all through her childhood. She had been a lesbian most of her life and saw men as a means of financial gain. One day she took me to a high-rise in a very well-to-do section of Boston and introduced me to Robbie, a well-educated ex-school teacher. Two years before I met her, Robbie's husband, a student at Harvard, had jumped off the roof of his school, lunch bag in hand. Robbie was one of the highest paid call girls in Boston, and she was going to be my teacher. On the foundation of my previous training, Robbie would endeavor to teach me the business of prostitution. Robbie was as cold and calculating as they come when it came to the financial end, and was a born actress in action. That night

I had my first sexual encounter with a man for money.

It was not long before I had a small following of regular customers. It was as if I had been trained for this. Everything I was doing was all too familiar—except now there was no emotional attachment. Every encounter was a mini-drama, and I gave the best performance I could.

Drugs were an integral part of this lifestyle. One evening I was visiting a friend when her pimp approached me and said, "Come here...I'm gonna make a woman out of you." He offered me some white powder on a small spoon. By this time I was well acquainted with cocaine and had sampled and used every pill, drug and psychedelic on the market. But I had kept away from heroin, thinking you had to use a needle—and that petrified me. This looked easy, so I took his offer. Shortly thereafter, every day became a ritual: I would make enough money to buy a bag of dope and a new outfit, and hit the clubs until the wee hours of the morning. We partied hard and long. Many well-known men passed through my life during this time: musicians, comedians and men now in key government positions. Life was fast, and money and drugs were plentiful.

My third year in Boston started and ended without Mary. She had introduced me to prostitution, cocaine and all the connections that I needed to survive. I had taken a studio apartment on one of Boston's main streets. I continued to make money in the daytime and party all night. One evening my roommate

and I met some men from New York, and they invited us to go back with them. Off we went in the wee hours of the morning. One of the men was Italian. He stirred a certain familiarity within me that caused me to have a false trust in him. He was a drug dealer par excellence, specializing in heroine and cocaine. He had a red horizontal line running through the center of his eyes and told my roommate and me that he had pledged allegiance to Satan. He showed us a ring that he proudly wore on his finger.

He was also a pimp and had women in New York—a detail that he failed to mention to us. Jaspar's women were all different. Now, some thirty years later, a few of them still stand out in my mind. Rhonda had been with him for twelve years (like a wife); Kim was in her early twenties and had only been with him for two years. Kim's mother, also a prostitute, had coached Kim as she turned her first trick at the age of ten. And then there was Angela, a girl from Canada. Angela seemed to be Jaspar's favorite. I wonder as I write this whether any of these girls are still alive. I pray that they have found Jesus and that God is restoring all things.

My roommate and I woke the next day without full recognition of what we had done. As we entered the living room of this expensive high-rise apartment on New York's upper east side, there were two mountains of white powder on the circular glass coffee table where Jaspar and his companion had sat all night. Reality hit! We wanted out of there! We made our desires known, but Jaspar turned to his compan-

ion as he scraped the side of his neck with the blade of a six-inch pocketknife saying, "Tell Donna what happens to girls who want to leave New York once they're here." My roommate, who was a real player herself and well acquainted with such scenarios, made some excuse and, before I knew it, was out the door on her way back to Boston.

Once again I found myself in a new environment with a new set of rules. I played the game for the next several months. There were requirements and financial quotas to meet. Several of Jaspar's girls were street hookers. I had been trained as a call girl and took pride in the fact that I never had to work the streets, so Jasper allowed me to work with Angela. Angela had several high-paying customers; unfortunately their obnoxious requests were as outrageous as the price that they paid. But my addiction to heroin had become an issue. Jaspar spoon-fed his girls every morning and intermittently throughout the day. We were carefully watched—if not by Jaspar himself, then by the other girls. It was very intense, and one always had the sense that you could never escape. One day I decided I had had enough. In a terrified frenzy, I packed a few belongings, went to the nearest phone booth, put in a dime and called my parents collect. With few words I shared my plight and they bought me an airline ticket to fly home. Within hours I was on my way.

Chapter 3

My Exodus

And it came to pass at the end of the four hundred and thirty years, even the selfsame day it came to pass, that all the hosts of the LORD went out from the land of Egypt. It is a night to be much observed unto the LORD for bringing them out from the land of Egypt: this is that night of the LORD to be observed of all the children of Israel in their generations.
—Exodus 12:41–42

*A*n exodus is a way going out or going forth. My exodus from New York City wasn't as extreme as what the Israelites experienced—and leaving held no real promises of Canaan for me—but being back home also created new challenges. For one thing, I hadn't lived in my parents' home for almost five years. My bedroom was now my dad's room, so I slept on the living room couch. I also had a heroin addiction and no finances or connections to meet the daily demands of the beast. My whole body was racked with nonstop pain. I had aches in places I didn't know existed. It seemed as if every fiber of my

being was crying out for the drug that I was so readily supplied in New York. However, I was not pressured so much that I would long for the "leeks and onions" that were back in Egypt as the Israelites did (Num. 11:5). No way!

The biggest challenge that I faced, however, was my memories of Michael. They loomed before me daily. It had been more than four years since his death, yet it felt like it was just yesterday. Time and my experiences had changed many things; however, all that I had run from was still alive and well.

I was twenty-two years old. I had been a hairdresser for one year prior to Michael's death, but had not developed any further skills that would help me to survive at a legitimate job; and I had an addiction to nurse. Where was I to go? What was I to do? You would think about now would have been a great time for Jesus to show up—and, oh, how I wish that He had; but I was still so wrapped up in me that I couldn't see beyond that veil of deception. I know He was just waiting for me. I'm sure I passed Him by daily and didn't notice my Savior, my Great Redeemer.

About this time I remembered a pharmacist that I had known in Boston who used to get us pure pharmaceutical cocaine. I knew he would help me—for the right favor. He did. He supplied me with pills to help lessen the pain, and I literally weaned myself from heroin over a period of time. My cousin persuaded me to get a job hairdressing at the local mall and to rent a house with her on the beach. For the next ten months, that is what we did.

Marie was a motivator in my life. We had grown up next door to each other, and she was like a sister; even closer at times. She was with me the night Michael was killed and we were bonded together because of it. She stood by me through everything. Even when I left town during the trial and she had to be shut up in a hotel with police guards, she never once questioned me.

I did the hairdressing job at the mall and continued to party and frequent gay bars. I left the friends I had known through Michael and endeavored to meet new ones. I was trying to get as much space as I could between myself and the past, and having friends of a different nature helped. I continued to follow the occult. Even eating healthy food began to appeal to me. I remember one lady who worked in a health food store that I frequented. She was in her fifties and looked twenty. One day I went into the store and saw her eating grapefruit and a handful of sunflower seeds. *This must be the way*, I remember thinking. Several weeks later the woman was no longer there. When I asked about her, I was told that she had died of a brain tumor.

During these meditative moments as I look back and write this account of my life, I see that every time I thought I had found the right road, it turned into a dead end. Like the time I was attending séances regularly; I turned down the street to the home of the medium where the séances were held and looked long and hard at the sign. It read, "Hemlock Street." For quite some time I had studied

and used herbs, so that day when I looked at the sign I remember thinking, *How can this be good when hemlock is a deadly herb?* I believe the Holy Spirit was trying to reveal the truth to me.

Marie and I continued to party at the beach house, but when spring came to a close, so did our lease. I had noticed a basement apartment just up the beach from where we lived and inquired about renting it. It was available and became my next home. The apartment was in the last house before a long stretch of beach. In the months ahead, it became the environment for much poetry writing. It was my own private place of existence. I didn't have to let anyone in if I didn't want to. (That became very apparent one day when my sister and mother drove thirty minutes to visit me and I wouldn't even let them in the door.)

The kitchen in the apartment had one red wall and one green wall, and the refrigerator was painted green with yellow polka dots. What a haven! I spent many long hours alone there. It was as if I needed a place to sort through the previous seven years.

I was now twenty-six years old. I became disinterested in hairdressing, as I grew tired of women complaining about the same trivial things every week. Many times I wanted to really curl their hair by telling them just a portion of what I had experienced in my short life. I decided to study psychology and took some courses at a local community college. If I were to counsel, I decided I would rather it be from behind a desk than a beauty salon chair.

Further along the beach, on a cliff, stood an old

mansion—like those you see in movies. During my frequent walks on the beach, I would look at that mansion in amazement and fantasize about how it must have been years and years since it had been occupied. I soon found out that it was *still* occupied. It was a private nursing home run by nuns straight off the boat from Italy. I decided that I would inquire about a job.

I can still see the waiting room as if it were yesterday. Directly in front of me hung a crucifix the size of a door, and on it hung Jesus. I remember thinking, after all I had been through, surely this would be a safe environment for me. Being raised as a Catholic, I felt comforted by the crucifix and thought that my family would approve and see that I was making strides in the right direction.

Now I must interject—at this particular time in my life I was still steeped in the occult and every New-Age idea that came down the pike. I had taken several courses in astrology and had spent hundreds of dollars on books to delineate charts; I attended weekly meetings and was a dedicated member of the Astrological Metaphysical Research Association, spearheaded by a very well-known medium in the area. I continued to attend séances on deadly Hemlock Street, and at night I slept under a pyramid that was aligned to true north to stop the aging process. I was very concerned and well read about eating right and fasting for optimum body health. My poetry was pacifying my emotions and my drug use was at an all-time low: pot smoking and an occasional bottle of wine. My addiction to sex was maintained

and kept alive by various lovers when the need persisted. I was doing great! And now a job for Jesus! Wasn't I cleaned up? Life just couldn't get any better.

My interview with the director of nursing and Father Chenzo went well. The director was aggressive but friendly, and seemed to rule the roost; and Father Chenzo...well, let's just say he was yet to come forth. But it was the residents who captured my heart. There was Mrs. Brown from Boston who daily put red, red blush and applied lipstick to the tiniest lips I ever saw. She was adorable. And there was Sarafina, who continually said *"sa frette"* (Italian for "I'm cold"). I hope they are in heaven today. Had I known Jesus at that time, I can assure you that they would be.

I found out about myself at that job. I found out that I had a love and compassion for people. Most of the reprimands I got on the job came from taking too much time tending to people's emotions. The Sisters seemed more concerned that we "get 'em up and move 'em out."

Father Chenzo kept a close eye on me, as if I knew something but he just couldn't quite figure out what it was. One day the cardinal from a major city came to visit and make his rounds. As Father Chenzo passed by with the cardinal, he pointed at me and said, "Watch out for her; she's hot stuff."

What? I thought.

In the days ahead he began to reveal his true self to me. At times he would call me into his office and dance all around certain issues, none of which I understood. I would leave there wondering, *What's up*

with this guy? Now I understand that he was fishing for me to open a door to him, because he didn't know how to turn the handle himself. It wasn't long before old, not-so-slick Father Chenzo took off with the director and fifty thousand dollars. Meanwhile the "Sisters" were running a close second to Father Chenzo in their deceptive talents. So much for my safe haven. However, though at the time I didn't recognize it was Him, God did use the experience to show me my heart for people.

Chapter 4

New-Age Deception

Regard not them that have familiar spirits, neither seek after wizards, to be defiled by them: I am the L*ORD* *your God.*

—Leviticus 19:31

My involvement with the occult never dissipated throughout this time. I touched all avenues available to me, from the Ouija board to tarot cards to chart reading to past-life reading to weekly séances...and finally to so-called white magic. Each day was like watching a football game and knowing the outcome, I thought.

Astrology and occult predictions, no matter what medium that you use, box you in. They allow no room for growth outside the boundaries of your sun sign's designated personality traits, other chart delineations and false prophetic predictions.

As God's Word tells us, "For the idols have spoken vanity, and the diviners have seen a lie, and have told false dreams; they comfort in vain" (Zech. 10:2a). I continued to attend séances regularly, and most of my friends were astrologers or mediums. One particular lady was always ill. She was underweight and frail, and

would always be swallowing tablespoonfuls of peanut butter during our meetings—"for her protein count," she said. Although I never understood, the Holy Spirit continued to reveal certain things to me through all this. I remember thinking, *If astrology and the occult is "the way," then why is this woman, who was deemed brilliant in the things of the occult, so sickly?*

I interpreted everything in my life in terms of New-Age philosophies. Colors, numbers...everything meant something. Even my sleeping arrangement and my diet became part of this search for perfection and truth. I fasted weeks at a time; not for spiritual reasons, but to purify my body. I became overly conscious of what chemicals I had put into my body. I believe that God used my obsession with right eating and fasting to prepare my body for childbirth, which—to my surprise and delight—was in my immediate future.

The séances that I attended on Hemlock Street were a paradox in themselves. When you walked into the house, it was not uncommon to see a Bible on the table. A picture of a Native American hung on one wall and a picture of Jesus was on the other. A variety of people attended; some church going. Once the activity got started, the "familiar spirits" would start telling things on people; people who were having a good time deceiving everyone and making a show of it. There were adulterous relationships going on in the group, and a variety of other unmentionable absurdities. It was a circus, and the devil was at the center as the master of ceremonies. His demons provided the

entertainment, and we were the captive audience. "And when they shall say unto you, Seek unto them that have familiar spirits, and unto wizards that peep, and that mutter: should not a people seek unto their God? for the living to the dead?" (Isa. 8:19).

After leaving my "haven of rest" job at the nursing home, I started doing past-life readings for an income. I recall the power I felt as I tapped into the negative side of the supernatural realm. Today, after years of walking with the Holy Spirit, I know the deceptions of the enemy through New Age are a poor counterfeit compared to the reality of God and the move of His Spirit. The enemy's tactics are like a cheap imitation of a fine painting, and only a discerning eye and heart can see the falseness of his endeavors. Thank God for the Holy Ghost!

My dedication to the belief system of reincarnation ran very deep; the foundation had been laid in those early months after Michael's death. Karma (the belief that you reap in one life what you have sown in another), and its so-called repercussions, was an ever-present bondage that operated on all levels: spirit, soul and body. Again, I watched my life and the lives of others based on astrological findings and the false prophetic predictions that stemmed from a variety of deceptive New-Age teachings.

It is obvious to me now that all the ways that we seek freedom outside of God just wrap us up tighter into every type of bondage imaginable. There is only one way, one truth and one freedom—and that is through Jesus Christ. Anything outside of Him,

although it may appear to have *some* truth and similarity, is false.

My search continued for some type of truth that would relieve the pain in my life, but the reality was that all those seemingly right paths just continued to lead me away from the real answer. How crafty the enemy is at leading God's blood-bought children astray! He takes advantage of the smallest amount of territory that he can render useless for God. Thank God for the blood of Jesus and His delivering power.

Astrologers, mediums and the like are a very strange group of people. I knew some who had a sincere desire to help people and were very gifted; they were just serving the wrong kingdom and master. I am sure if they could see the likes of the "familiar spirits" that they put so much faith in, they would run the other way. Some mixed religion with their psychic gifts to justify their involvement with New-Age practices. Others took pride in the power they had over other peoples' lives as they offered their advice under the deceptive guise of an "I can help" attitude. My own involvement was rooted in those very same beliefs. I was, and always had been, an enabler. This probably stemmed from my mother's extreme needs when I was growing up. I developed a false sense of "I can help," out of a situation based on "I must help."

My involvement with the various humanitarian aspects of New-Age philosophies fed my deep-seated need to help others, but was founded on misconception, deception and submission to the wrong kingdom. I had always gravitated to the underdog.

Relationships with the men in my life were always rescue missions. Unfortunately, when you become involved with someone outside of God, the relationship doesn't even bear a slight resemblance to what a godly relationship looks like. Astrological compatibility is based on what your charts dictate, and relationships founded on those predictions are dry, to say the least. It is like drinking a glass of water and still having a dry mouth. There is no real satisfaction in anything that does not involve God. No matter how impressive New-Age practices appeared to be, something was always missing. There was a place on the inside of me that had been stuffed with all kinds of things through the years, but none of them seemed to quench or fill the emptiness that I felt.

Chapter 5

The Journey Begins

For ye shall pass over Jordan to go in to possess the land which the Lord *your God giveth you, and ye shall possess it, and dwell therein.*
—Deuteronomy 11:31

I was now twenty-seven. I had never wanted children—or, let's say I never really gave it much thought. I suppose that I figured I would never marry, therefore having children had never really entered my mind. But God knows and He makes no mistakes.

Within two years time I found myself not only a mother to one child, but also a stepmother to two other children.

My daughter Zoë was born on a Sunday morning in August of 1977. She was birthed at home in four hours with two midwives, an aunt, a cousin, a friend and her husband standing by in an eight- by thirty-foot, bright yellow mobile home on Victory Highway. She was as pink as a rosebud. I delivered her and almost immediately got out of bed and did the birthing laundry. For the next three days we had a stream of visitors: family and friends. I chose Zoë's

name because it was the Greek word for "life." I didn't know that, a few years up the road, that word would have a much different meaning for me!

If there was anything I wanted for my child, it was life—and a good one, even though at the time I had no clue what that meant. Once the Lord touched my life, I would have a very different understanding about what it really meant and how much more expansive my options were.

Zoë's father was a few years younger than me, and the relationship was another one of my rescue missions. When we met, he was practicing a lifestyle that I had laid down, and I thought I could help him. He was confused and angry, and I could relate to both. I had grown up in an angry household and certainly I was familiar with the confusion of not knowing who I really was until I met Jesus. But, as with most people who have certain latent behavior patterns, what you see is not what you get.

I moved in with Zoë's dad when I was six months pregnant, and he moved out when she was six months old. The relationship was not fair to either of us. We were in different chapters of our experiences in life and, aside from the birth of our daughter, there was nothing to hold us together.

I loved my new baby girl, even though my parenting skills were lacking. It was new to me, but it felt right and I did the best I could with what I knew about mothering.

Zoë's dad sang and played the guitar. One night as he played, Zoë let out the most melodious sound as

she lay on my shoulder; She was only six months old and she was trying to sing. By the time Zoë was four, her talent for music was very evident. As time went on, many of her teachers encouraged her ability and suggested that I should guide her in that direction. Through the years Zoë had many awesome opportunities to use her gift, and her gift made room for her, always, as long as she yielded to God. Unfortunately, rebellion has a way of creeping in and souring the plans and purposes of God, at least for a season.

All relationships outside of God end the way they begin: empty, void and without form. Just as God breathed life into the non-existent atmosphere of the earth, He must be allowed to breathe life into all we are and hope to be. Although I attained motherhood through my relationship with Zoë's dad, it was just another emotionally painful ride to add to an already very long list. At the core of my being, I truly wanted to be loved. I was trying to satisfy and fill an ever-present emptiness, a longing that reached to the very depths of my soul. Life was like a puzzle, and I had tried all the different pieces in an attempt to fill a space that was predestined to be filled only by having an intimate relationship with a loving God. I had always had a genuine love for people and a heartfelt drawing to help, but I didn't know the Helper; therefore I always fell prey to abusive situations while trying to exercise a God-given gift. Once again the stage was set for the next chapter of my life.

Zoë and I remained in the small trailer on Victory Highway where her dad had lived and where she was

born. Next door lived two little girls who were being raised by their father. (Their mother had died seven years previous.) Suzie and Danielle were seven and nine when I met them, and I quickly saw that every single area of their life needed something! Are you getting the picture? Next! I was a brand new mother, unsaved and inexperienced about children. At twenty-eight, even all my previous experiences could not have prepared me for what would occupy the next seventeen years of my life.

Our trailers were but a narrow dirt path apart. That path would soon become a trail that connected me first as friend to the oldest child, Danielle, and then as a lover to her father. Harris, a well-educated and multi-talented man, was also an alcoholic. At first he appeared to be different than most of the other men I had had relationships with. At least he had a college degree instead of a police record. He ruled one child with a kid glove and the other with an iron fist, or so it seemed. My appearance on the scene brought an uninvited balance to the situation. The girls had learned to play the game, and they played it well—according to the rules that alcoholism dictated and the learned behavior that was generated in that atmosphere. They had no boundaries, and were totally unkempt. My heart went out to them.

Zoë and I moved in with the girls a year after her father left. Shortly after that I became pregnant with my third child. I remember the conversation as Harris sat on the couch talking to a relative on the telephone: "Tell her to have an abortion," was the

The Journey Begins

response to the news of my pregnancy. I was so confused that I didn't know what to do. The relationship was already under a major strain because of Harris's drinking, and the problems and pressures of raising children in that environment seemed insurmountable. I left and went to stay with an aunt for a week to think things over.

I finally decided to have a second abortion. (This one was legal.) I remember the nurse speaking to several of us at the hospital where the procedure would be performed. She said that what we carried inside us was not a baby; it was nothing more than a quarter of a cup of jelly. I was twenty-nine years old, three months pregnant, and just as ignorant as when I was seventeen. I remember the day well. I wrote the following, called "Aborted Delivery," to my daughter Zoë recently as she was at a crossroads in her life. Although her decision was not related to the abortion of a baby, it was a decision that would greatly affect every area of her life; and, if the wrong path were chosen, it would have aborted the delivery of God's plan and purpose for her life, and her child's.

> *I sat up on the surgical table crying convulsively.*
>
> *"If you didn't want an abortion why did you have one?" said the attending nurse sarcastically.*
>
> *I stared at the floor only to see the bloodstained white patent leather shoes of the*

doctor. He stood at the end of the surgical table next to a vacuum-type machine that moments before had so effortlessly sucked the life of my third child from my womb; a place that God intended never to be intruded on by man. It would be many years before I would understand the grief that was attached to that decision and how the course of my life would change as a result of the twenty minutes that I spent on that table. Unknowingly that day I was robbed, as were my other children, of a lifetime of joy, and a relationship we would never know the blessing of. Forgive me, Joseph. I love you.

Through the course of my life I have aborted other deliveries (though not children), through decisions I have made. Through the years I have learned to carefully consider the cost, weigh the result of my choices on both sides, seek counsel, and then move. It has been a long painstaking process to get there and by no means am I at this point in time free from making wrong choices. However, as I have overcome my addiction to inferior pleasures and outgrown my need for suffering, cycles have been broken and I now stand with an earned knowledge and authority to speak openly and honestly to others in similar situations.

> There are many decisions that we must make
> throughout our lives. Some are small whereas
> others change the entire course of our lives.
> However, most change brought about by our
> choosing one path over another in life does
> not bring a shift into neutrality. It has been
> my experience through the years that all deci-
> sions will either have a positive or negative
> effect on our lives and those closest to us.
> When the decision we make is a positive
> move, we can expect our maturity and growth
> to be brought to fruition, God's plan and
> purposed to be fulfilled, and a peace and joy
> to consume us like none other. When our deci-
> sion causes a downward spiral of our life
> physically, morally, and spiritually, we abort
> the processes of God and His delivery to us of
> all good things. We abort the delivery, and
> like the story at the beginning, the rippling
> effects and consequences of our choices will
> reach far into our future.

At the end of that year, 1979, Harris, his two girls, Zoë and I moved to Colorado to start a new life. Zoë was two years old. There were tremendous needs to address daily with the girls and Harris now a part of my well-rounded, codependent personality. My little girl, who once had all my attention, was now part of a daily tangle of unmet needs and undisclosed emotions. I had now incorporated her into the

roller-coaster pattern that was prevalent in my life for so many years. My relationship with Harris had not started well and, even seventeen years later when it ended in divorce, there remained much unfinished business. Once again I had gravitated to an angry personality, and once again I had begun a relationship based on my sexual appetites and a misdirected drive to rescue.

Settling in Colorado was unexpected, as the initial plan was to go to Arizona where Harris and the girls had lived prior to coming back east. Colorado was visually beautiful, and that somehow colored all that was going on inside me. It promised freshness and birthed a hope inside me that perhaps things would be different here. We ended up in the southwest corner of the state, in a valley located eight thousand feet up in the mountains, on the second largest man-made lake in Colorado. We rented a house that was part of a resort for the first year, and then bought two twenty-foot-square cabins that had been built in the forties. These cabins had once housed the workers who built the dam that formed our lake—Lake Vallecito ("little valley").

The visual change, though refreshing at first, didn't alter the deep-seated wounds and baggage that we were all carrying from our past. Tremendous emotional outbursts controlled our lives daily. Crime I knew; and drugs I had been well acquainted with...but the spirit of alcoholism was new territory for me. It poisoned everything in its sphere of influence. It hurt, tore and devoured everything in its

path. The emotional devastation of alcoholism, coupled with my own baggage, was more than I could bear at times. And the children, who had once found refuge in my friendship, now seemed to resent my very presence. My feelings towards them changed from compassion to full-blown resentment. I was at my limit in every area.

The enemy had come in full force but, like a flood, the God I didn't know or acknowledge was about to raise up a standard against Him: my salvation. God's Word states: "God commendeth his love toward us, in that, while we were yet sinners, Christ died for us" (Rom. 5:8). God loved me, and He was soon to make a way of escape that I could not have planned or perceived. "God setteth the solitary in families: He bringeth out those which are bound with chains" (Ps. 68:6). He was about to set a "solitary" in a family.

Chapter 6

A Way of Escape

There hath no temptation taken you but such as is common to man: but God is faithful, who will not suffer you to be tempted above that ye are able; but will with the temptation also make a way to escape, that ye may be able to bear it.
—1 Corinthians 10:13

Jesus was not an unfamiliar name to me. Growing up as a Catholic, I bore much responsibility for knowing who Jesus was; however, I was never told that I could have a real relationship with Him. My sister had come to know Jesus through the "Jesus Movement" of the early sixties, when it became "in" to know Him. I not only rejected the idea that "He" could be the answer to all my problems, I wouldn't even admit that I had any.

In reality, my life had always been in turmoil. Now I faced each day prepared to respond to any emotional roller-coaster ride that I was exposed to. I remember one visit that my parents made to Colorado to see us. After much observation, and no admission from me, my dad said, "There's got to be

some kind of pain going on here." I just looked at him blankly and denied it. On the inside, though, his statement became a reality check. I *was* in pain—tremendous emotional pain and turmoil…and so were my children.

Then something happened. Zoë and I hitchhiked to town one day to pick up our truck. Not far outside the valley, a car stopped to give us a ride. Destiny had rung its bell and I was on my way to dinner, like it or not! The Old Testament describes it well: "And the LORD said, I have surely seen the affliction of my people which are in Egypt, and have heard their cry by reason of their taskmasters; for I know their sorrows" (Exod. 3:7). God had seen the anguish of our lives and had heard the inner cry of my heart; a cry that I didn't even know was going up to Him. Little did I know that He would send a car full of Moseses to us that fine, crisp Colorado day.

The conversation in the car was nothing short of a verbal volleyball match. The people in the car told me about Jesus, and I told them about astrology. Back and forth we went; however, the seed was planted, the hook was set and the wheels and course of my life were set to change.

A few days later, as I was driving into town to shop, I was thinking about what those precious people of God had said to me. Right away the enemy came to steal. I heard: *Look, you don't want to burden Jesus; He already has so many people depending on Him.* I remember feeling a twinge of compassion as I almost agreed with the statement. (God's people perish for lack of

knowledge, and the devil always comes to steal the precious seed of His Word; Hosea 4:6; John 10:10.) That would be one of many lies that the enemy would try to feed me as I began my transition from darkness to light—but each time the Spirit of God would come and show me the truth.

I had more conversations with the precious messengers that God sent in the car. Marvin was a Baptist and his wife was Pentecostal. She stood by patiently one day as they visited me. Marvin was sharing the gospel—with illustrations and all—as best he could. Even in my newness to the things of God, I could tell that he had never led anyone to the Lord before; but his love and willingness was genuine. I listened intently as he shared the gospel, using arrows and a drawing of the cross on a small piece of notepaper. They bought me a Living Bible and I began to read it. Daily I faced the God I had feared as a child. (I had been told when it was lightning that He was angry with me.) Daily I challenged Him to reveal Himself to me—if He really was all that those precious ones had said He was. In my own sarcastic way, I surrendered my heart to Him.

After that, I began to read the scriptures daily. Since I didn't know any better, I started at the beginning. As I was reading through the book of Genesis, I came upon the name Asher, a name given to one of the twelve tribes of Israel. This Hebrew name, which Leah so proudly chose for her son (Gen. 30:13), meant "happy, blessed, honest" and "proper." I remember thinking, *If I ever have a son, I will call him*

Asher. Within weeks of that declaration, I found a tiny steel-blue letter sweater in a local thrift store with a large gold "A" on it. I didn't know God or His ways well at this time, but I had an inner knowledge that there was a baby coming, that he would be a boy and that I would name him Asher. I didn't know at the time that it was the working of the Holy Spirit, our Helper, our Comforter and our Advisor, and that He was teaching me to trust that voice on the inside. In the years ahead, I came to know and trust in this inner sense of confidence.

Asher was conceived shortly before we purchased the two small cabins overlooking the lake. Asher was born seven weeks early, on December 28, 1980, in one of those cabins.

The emotional turmoil caused by alcoholism does not go away when change comes to a household…even if the change is a beautiful baby boy. The enemy tried to take Asher's life from the beginning. Since he was born prematurely, he had recurring lung problems and was often sick. But there was a call of God on Asher's life that was evident from the beginning. He saw into the spirit realm at a very young age. Once, at age three, he said that he saw Jesus and he kept repeating a phrase that we could not understand. Finally a year later we understood him to say that Jesus had a chainsaw blade wrapped around his head. To a three-year-old who was familiar with cutting wood, I guess that was the best way that he could describe the crown of thorns.

The enemy never seemed to let up on Asher. At one

point, we purchased a horse from a friend and had him "green broke." After his six weeks of training at a local ranch, we all went to pick up "Blessing." We were so excited when we saw the horse that we didn't see Asher fall into the river. When I finally turned around, there was my precious little three-year-old, soaking wet. We were later told that he had caught onto a root that was coming out of the side of the riverbank and had pulled himself out of the water. Have you ever witnessed a Colorado river? Even the smallest of them are very fast moving and certainly not a safe place for a child. But God and His angels rescued my precious little boy.

Other incidents happened closer to home. Asher played with a little boy his age who lived in the cabin next door. The boy's mother and I were close friends. Asher and Phillip spent much of their time outdoors in the beautiful scenery and crisp mountain air. Since we lived adjacent to the mountainside, it was not uncommon for us to see all kinds of animals passing through our property. One day the kids came in and wanted me to see the "baby bear" that had wandered onto our property. I complied and found a porcupine, not a bear, in our yard. That day we spent several hours pulling quills out of our very protective dogs, Provo and Muffin.

Another time Asher and Philip decided to climb up the mountain that bordered our property. My neighbor and I were visiting on the phone and I lost track of the time, until we heard Philip yelling for us. We scrambled up the steep incline following her son's

voice. When we finally met up with him, he kept saying, "Brick, brick wire; brick, brick wire." Halfway up this particular side of the mountain there was a huge waterfall. Suddenly Asher came into view and we learned that, a few feet before the edge of the waterfall, he had caught his clothing on a piece of barbed wire that had spared him from falling to his death.

There were many attacks on Asher's life as a child, but there were also many wonderful dreams, visions and prophecies over him. Some have yet to be fulfilled. I, like the mother of Jesus, always treasured these things in my heart. Each time the enemy rose up to steal Asher's life, I would hold the truth in my heart and discern fully, keeping a watch in the spirit to protect the gift that God had given me.

A few years later, Jed was born. I wanted so much to have another name chosen from the scriptures by the Lord, but Harris announced that he wanted to name this baby Jedediah, after the mountain explorer Jedediah Smith. On the day of Jed's dedication, I went to church heavy with disappointment because I though that he wasn't going to have a name from the Bible. But, when the pastor read the text for the dedication, it was in reference to King Solomon and it read, "And he sent by the hand of Nathan the prophet; and he called his name Jedediah, because of the LORD" (2 Sam. 12:25). God had given me the desire of my heart, and I had had no clue! He had been faithful. I later found out that Jedediah means "beloved of the Lord." I was blessed!

We had arrived in Colorado in 1979, and it was

now 1984. I had been a member of the body of Christ for almost four years. I was fanatical and gung ho for Jesus, though I still lacked much understanding about the strongholds and soul ties from my past. Our home life didn't get any better. My salvation, and the fact that I was taking the children to church, made some things appear better—if only temporarily. I was beginning to learn how to find "that place" in God. Raising five children in a twenty-foot-square cabin with an alcoholic husband continued to present major challenges, but I had found Jesus and nothing could change that! I had served the devil well and I fully intended to serve my God even better.

The Lake Vallecito valley was quiet once the tourists left. If I played teaching tapes during the day, you could hear them reasonably well from outside—and I played them loud! I wanted the devil to know that I was taking back what had been taken from me. I became more and more aware of spiritual warfare. At the time, playing teaching tapes was one of my weapons against his daily onslaughts.

At this time, we built redwood patio furniture and had a consignment shop in one of our cabins where we sold local crafts. An accountant named Joan would come to do our books. Joan was in her late forties and had been a lesbian since the age of eighteen. I understood her and I loved her, but I wanted her saved. When she came to the store to do our books, I would usually be playing Kenneth Copeland tapes full volume. She said later that those tapes stuck in her spirit after she left and eventually they helped

create a hunger in her for God. You guessed it; Joan was saved several months later at our pastor's wife's Bible study. Her salvation was miraculous and life changing. (Years later she went on to work for T. L. and Daisy Osborne.)

Another woman a few cabins down from me had three little girls. Jackie and I would often smoke pot, drink and visit while our kids played. When I got saved, our relationship changed. One day she was in my kitchen and I said, "Jackie, you've just got to get saved." She said, "From what!" Being newly saved myself, I didn't have the answer. I felt intimidated. From then on I read my Bible so I would be ready when she visited again. One day I invited Jackie to a Bible study. She declined; but within a few minutes she was back on the phone with me. She told me that, after she'd hung up the phone, she turned on her stereo and went to the sink to do her dishes. Immediately her stereo turned off. Twice more she turned it on and returned to her dishes, only to have the radio shut off again within seconds. She said at that point she felt she should come to the Bible study—and she did. Jackie did get saved, but had a hard time committing for various reasons. I would like to believe that she is out there today serving God.

My zeal for God as a new Christian consumed me, yet my ignorance about His Word and ways limited me. I continued to witness to all. The sweet Baptist that had led me to the Lord made the comment that no unbeliever was safe on the lake, now that I was saved.

Life in the cabins was hard. We would lose electricity frequently in the winter, and our pipes would freeze. We had rented out one of the cabins and attached a trailer to the other. Unfortunately the only working toilet was in the rented cabin. As hard as it may be to imagine, we would line the toilet in the trailer with a garbage bag and daily the older girls would have to remove the bag and walk several hundred yards to the boat dock outhouse to dispose of it.

Washing clothes was an all-day affair, as I had to fill the washer manually with a hose. To have heat in the winter, we chopped our own trees and cut up ones that were already on the ground from the previous winter's storms. Everyone helped. There were times when the woodpile was encased in ice and I literally had to dig wood out of the pile. Then the wet logs had to be partially dried by the stove before we could use them. I split wood throughout both of my pregnancies; in fact the people who led me to the Lord told me that they prayed for me as they passed by the cabins and saw me out there, full bellied, swinging the axe.

One day as I was going about my daily chores, the Lord spoke to me. He said, "Pray for three acres in Bayfield." Bayfield was a small town about thirty-five minutes away where we would sometimes shop. I told my older girls what the Lord had said, and we agreed in prayer. I held that prayer up to the Lord often over several weeks.

Chapter 7

Miracle on Rainbow Road

I do set my bow in the cloud, and it shall be for a token of a covenant between me and the earth.
—Genesis 9:13

Just as God looked down on the Israelites and saw the anguish of His people, I know He truly felt the pain that my children and I were experiencing. His ear was not so far removed from hearing, and His arm so short that it could not reach down and do something so miraculous that even to this day my children and I refer to this season of our lives as the "Miracle on Rainbow Road." As in any testimonial about one's life, it would be impossible to give a total account of all situations. However, I can tell you that this particular season was like none that I had experienced before regarding my encounters with the Lord. It was truly a "look-what-the-Lord-has-done" thing.

It was but a few weeks earlier that the older girls and I had agreed in prayer about what the Lord had spoken to me: "Pray for three acres in Bayfield." His voice was profound and distinct. It was Him speaking, not my imagination. God had placed a desire deep in my heart and then brought that desire to

fruition by telling me exactly how to pray. I prayed His word spoken to me by Him. This exercise in faith would build an unshakable foundation for dealing with future needs as I endeavored to obey and pursue God, not only in this situation, but also in many that were ahead of me.

The first stage of this miracle was when, for no reason and certainly at no request of mine, extra furniture began to show up at our cabins. Some friends who were leaving the area gave us a full living room set. Then in July some family members from Florida who owned a lamp factory visited and—you guessed it—they brought us several lamps. I remember sharing with one of them about the house that the Lord was going to give us. He looked at me as if I were crazy and said, "You'll never get my brother to leave this lake." What came out of my mouth surprised me. I said, "I don't have a doubt in my mind that when your mother comes in September, I will entertain her in our new home."

A word about the furniture blessing: At the time we had two twenty-square-foot cabins and hardly enough room for ourselves and our own belongings. Let me paint you the picture. Can you fathom a twenty-foot-square area, possibly your living room? Now divide that into four sections. As you entered one cabin, the kitchen was to the left front. The top of my washer served as my kitchen counter. To the right was the living room. The old claw-foot bathtub, which we filled with a hose and hot water from the sink, had a board and cushions on top when it wasn't

in use so it could double as a seat. Prior to its use in the living room, it had been a bed in the left back bedroom that the three girls shared. The back right bedroom was my husband's and mine. We slept on a mattress on a wood platform with storage underneath. Suspended from the ceiling by four thick ropes was a board that held a crib mattress for Asher, until Jed came along. We lived in Colorado for six years, three of which were in that cabin.

Was it not God who looked down and was moved by our faith and blessed by our obedience to pray a prayer that in one breath changed our destiny? Our faith and our obedience in prayer sends God a strong message. Many pray without faith, and some pursue faith without prayer. Prayer and faith are the eternal dance partners whereby our needs are met. They are the vehicles that move us from one realm of God to the other. We can walk to the store, drive to the mall, fly or sail to other parts of the country or world. Each vehicle of transportation has its limitations and causes us to transition to the next available means. It has been my experience that successful prayer experiences catapult us into not only the next level of believing, but also into the next level of prayer. Such was my learning experience through the Rainbow Road prayer project.

One day not long after the Lord spoke and the girls and I agreed in prayer, Zoë and I went into Bayfield, as was our custom, to do some grocery shopping and to stop by a farm where we bought raw milk. (It was the kind of milk that, once settled in the glass gallon

jar, would produce four to five inches of cream at the top. It was great—and worth the trip!) In the supermarket, an ad on the bulletin board caught my eye. It read: "House for rent. Large barn and outbuildings on three acres." The "three acres" screamed at me! I wrote down the address. As we left the store en route to get the milk, I realized that the house was on the same road as our dairy farmer. When we approached the area, I looked to my right and saw a winding driveway lined with Swedish Elms that led to a house with a large red barn in the back. There was a pasture on the left, an apple orchard on the right, and several smaller buildings were scattered around the property. I took a long look and continued up the road to the dairy, deciding that God could not possibly mean *that* house; it was too good for us. What a lie!

To make a long, very wonderful story very short, against all odds, within a few weeks we moved into the farmhouse on Rainbow Road. The day that we moved in, Suzanne, my youngest stepdaughter, made me a wooden plaque, which I still have today. It read, "God Answers Prayer." Oh, and by the way, we picked up my mother-in-law the evening of the day that we moved in. Faith-mission accomplished!

Recently I read a book about a woman who has a ranch where people from all walks of street life—drug addicts, prostitutes, criminals, and so on—come for restoration. Over the woman's desk hung this phrase: "The eyes of faith are blind to circumstances." That phrase has stuck with me. The miracle on Rainbow Road was like that. God spoke to me. This is one of

the few times that I have heard His voice and His will so directly. Once God spoke, there was no devil from hell who could convince me that God would not do His part if I did mine. The end result was signed, sealed and delivered as far as I was concerned.

The Miracle on Rainbow Road was many faceted. The house became the cocoon where my children and I had some of our most profound experiences in God. Our time there was a season that will always remain a testimony in my mind of God's faithfulness and mercy in the most trying of times.

Chapter 8

Precious New Beginnings

Now therefore stand and see this great thing, which the LORD *will do before your eyes.*
—1 SAMUEL 12:16

We settled into our new home like melted butter on a hot muffin. We filled every nook and cranny of our newfound space, and it filled us. The extra room and conveniences alone brought a certain peace. It was heaven to the kids and me, and God did it! It was our trophy of prayer and a monument to a loving and faithful God. As soon as God gave it to us, He began to occupy it.

Even with all the joy and contentment of a new home, the teenage years are "no respecter of persons," and my oldest stepdaughters were coming on fast. Danielle was always a very emotionally troubled child, and those areas just grew stronger as she entered her teens. She was also a very loving and helpful child. She secured a job at a local nursing home, and that in itself led to new freedoms. Then she acquired a boyfriend and—in one rebellious, hormonal frenzy—she ran away for a week.

Once Danielle returned home, my attention

turned toward Suzanne. This was not due to misbehavior, however; It was because God was blessing us with some very special events.

A few days before Danielle returned home, my youngest stepdaughter, then thirteen, began to have visitations from the Lord. This seemed to come at a very appropriate time, since the church that we had attended the past three years had just been devastated by the fact that our pastor's wife had run off with the associate pastor. We went from house to house attending to each other's shattered emotions. We no longer had a tight church family; we now had a group of people who were hurt, angry and totally thrown off balance by the situation. Yet somewhere in it all, God saw to it that each one of us had what we needed.

Why he chose to bless us especially during this time, I'll never know. Perhaps it was for the children and the call that was on their lives; perhaps it was to help a mother who held on to the church like it was the feet of Jesus. Was it not supposed to be? Daily we were confronted with a scattered church body and shattered emotions, yet God chose to do what He did in our lives. At a time of utter weakness, He brought the strength of His presence in a way that could not be denied nor ignored, and it came by way of a very shy, introverted, thirteen-year-old girl. The ride began and ended in a matter of six months.

Here's what happened. Suzanne would wake up most nights and see a big gold chair at the foot of her bed. As soon as she climbed up in the chair, she would

find herself in heaven. Yes, I did say heaven! The Lord began to appear to her almost nightly. Sometimes she would hear Him audibly; other nights He would escort her around heaven, showing and telling her many, many wonderful things, some of which He told her she could not share. He began to show her the spirits that were operating in our home and in the homes of several members from our church.

It was a very exciting time, though in my newly saved state I did not totally understand it. The Lord would wake Suzanne, calling her "minister to the world." It was as if the children and I were living in a supernatural time warp. Daily Suzanne would descend from her bedroom on the second floor of the farmhouse and I would say, "What happened last night?" Then we would all sit and listen intently as she told the events of the evening before. Zoë was six, Asher was three and Jed was just a year old at the time. Once, as we sat listening to the previous night's adventures with the Lord, Suzanne said, "You were praying last night." I told her that I was, and asked how she knew. She said, "There were sparks coming from the house." She told us she and Jesus were looking over the earth, and there were sparks coming from several areas all over the world. She commented that some of those sparks reached heaven and some didn't. When they did, Jesus would reach out His hand and the sparks would turn into a scroll. As He opened each scroll, He would say, "That's done!" She told me she had tried to read the scrolls, but they were in another language. At one point she asked Jesus why some of the sparks

(prayers) reached heaven and others didn't. He told her that the prayers that reached heaven were the prayers that were backed by faith and the declaration of His Word (Heb. 11:6; Rev. 12:11).

This is just a short account of many, many wonderful words and experiences that the children and I shared during this time. Why God chose to bestow such a blessing on us I do not know, but we relished every day with great expectation and enthusiasm for what He would do, say or show to Suzanne.

Meanwhile, back in the big red barn that you could see from the road as it towered over the house, a man continued his cycles of abuse—first of himself and then of others. Hurting people hurt people. There seemed to be no change in Harris's life, and no end to his indulgences. Before the church disbanded, the children and I were surrounded by a close circle of friends who loved God and saw our pain. But Harris never seemed to be affected by what was happening in his own family and home.

I have to say at this point that Harris was a very caring and sensitive man at times. He had a tremendous amount of pain and a large number of unresolved issues in his life long before I met him. He was very talented and intelligent, and God had spoken to him of his destiny when we were still living back east. The call had come; the response had not. On several occasions I had seen him make a real effort to serve God, but his disease always got in the way. Although the children and I were in a season of mighty visitation from the Lord, his basic belief was disbelief. He

said many times that he felt Suzanne's experiences were not true.

Believe it or not, some of the people I respected for their spiritual insight and maturity felt the same way. "Suzie?" they would say. "Surely not Suzanne!" Yes, the very people that I looked up to and looked to for guidance, doubted that God could move mercifully in a family that was continually sabotaged by alcoholism. But God had set the solitary in this household and it was having a major affect on my life and the lives of my children. Suzanne's experiences continued in spite of the doubt and unbelief we were at times subjected to.

We had now been in the house on Rainbow Road for eight months. We had tried to sell the lake property in hopes of purchasing the farmhouse, but God had other plans. One day we received a call from the landlady. She had given us first option to buy the house, but, because we were not able to purchase it, there was an eye doctor in town who was very interested. We had a little less than two months to move, as they had begun the paperwork to sell the property to him. The landlady, a precious woman of God, said the Lord had given her a scripture for us. It read, "For ye shall not go out with haste, nor go by flight: for the LORD will go before you; and the God of Israel will be your rearward" (Isa. 52:12). The stone had been set and the die had been cast. The children and I were devastated. We could not possibly go back to the lake property.

Several days passed. I was beginning to doubt God

and all that had taken place over the past several months. I went to bed one night and, as I turned over to face the other side of the bed, there right in front of me, suspended in midair, was a huge baby booty covered in every precious stone conceivable. There were blues and greens and purples—too many to count. All the next day I kept asking the Lord, "What was that about?" Finally He said, "Precious new beginnings." I told Suzanne about it later that evening, and she said that she had seen that same booty on a shelf in my home in heaven. God was about to do something...but what?

With a move imminent, we began to consider relocating to Tulsa, Oklahoma. A couple from our church had moved there just after the church split. This couple had been very instrumental in helping us work through some very tough issues, and we felt very bonded to them. Unfortunately, however, they were not supportive; nor did they seem to believe what Suzanne was going through in her experiences with the Lord. This raised great doubt in my mind; after all, they were our mentors.

When our lake property didn't sell, the owners of the house gave us a move-out deadline. They were going to close the sale with the eye doctor. Even Harris was convinced by this time that we could not go back to the lake. So, we began to prepare for our exodus from the security and comfort of our God-given farmhouse. We started packing all our belongings and all our memories from that great house where we had lived for ten months. It was a landmark

of many things for the children and me. We had had a watershed experience with the Lord there; an experience that we would always remember and draw strength from in the years to come.

One night as I was struggling with the reality of Suzanne's experiences, I awoke and looked across the hall. Asher and Suzanne were sleeping on two twin mattresses laid on the floor in the bedroom. I couldn't help but notice that Asher's body looked as if someone had moved it over to one side of the bed. I remember thinking how unlike Asher that was. Usually he woke up in the same position that he fell asleep in. He was always like that, even as a baby. The next morning when Suzanne awoke, she told me that Jesus had come to visit her during the night and had moved Asher's body over so He could sit on the mattress next to her. Unbeknownst to Suzanne, God was addressing my doubts. That made it final for me; I believed my stepdaughter and would never allow anyone, no matter how I esteemed them, to persuade me that her experiences were not real. We had come too far! God had spoken too much!

We packed up our belongings, made one last visit to the lake property, and Harris and Danielle headed for Tulsa to find work and a place for us to live. Suzanne, Zoë, Asher, Jed and I flew back east for three weeks to visit my parents. I was very protective of all the children during that visit. We had been in a spiritual cocoon, hidden in His Secret Place, for the past ten months. We were fragile and very sensitive.

Suzanne's visitations continued. One morning she told me that Jesus had come into my mother's bedroom, where she, Asher, my mother and I were sleeping. She said the side of the bed that I was laying on was glowing. She said that Jesus took His hand and laid it against the top of the wall on the side of the bed where my mother was sleeping. She said that when He removed His hand, in blood, His Blood, was the word, "SAVED!" Suzanne went on to say that Jesus then went down the hall toward my dad's bedroom door and she followed. However, He would not allow her to go into my dad's room with Him.

We flew back to Colorado where we met up with Danielle, who had driven back from Tulsa. We retrieved all of our possessions from a friend's barn and began our journey to Oklahoma. We left Colorado behind, and with it a balance of the miraculous power of answered prayer and the memories of a family torn by alcoholism.

The children and I had our own spiritual life apart from Harris. At the time I didn't fully understand the degree to which my godly desire to raise the children without the pain we lived in would be challenged in the coming months and years. Yet God had done something wonderful. He had given us experiences that few are graced with. He had shown Himself mightily and had laid His hand heavily upon the children and me. He had marked us and tattooed our names in the palm of His hand. The Master had touched us, and now that revelation was being carried to a new environment.

The anticipation of Tulsa was exciting for me, but leaving Colorado was bittersweet. I had found Jesus there. In a life that was filled with heartache and much emotional turmoil, He had touched my heart and had begun to change me from the inside out. We had friends there who cared for us in a way I had never known. My comfort was that you never lose your friends in Christ; we would meet again in heaven for eternity.

For the first six months in Tulsa, nothing seemed to move for me. Then one day the Lord reminded me that I could not enter into what He had because I was still clinging to what was. Slowly I let go of the old to receive the new. It was a process, the results of which helped me through other transitions that would be required in the future.

After six weeks in a tent that had been our home for the first month in Colorado, we settled into a house in the suburbs. It was September of 1985 and, without finances for Christian school, I began to offer my services as a teacher's aide in exchange for tuition for the children. (Danielle was already established in another Christian school and was paying her own tuition with a job she had secured earlier.) As a fairly new Christian, I thought because everyone in the school said they were Christians and we were in "Tulsaruselum," that they were totally righteous at all times. Yet I was seeing things and hearing things that disturbed my "pedestal positioning" of some of the people I was in submission to. Mistake #1: Forgetting that only God is perfect. Mistake #2: Not checking

and clearing out my own house first. Mistake #3: Forgetting that "there is none righteous, no, not one" (Rom. 3:19). We are all working through some process, transitioning from one place to another, from one level to another.

God did speak to me loudly and clearly regarding my concerns. He spoke out of the book of Jeremiah and used a word that I didn't know the meaning of at the time: "I have set you as an *assayer* and a fortress among my people, That you may know and test their way" (Jer. 6:27, NKJV; emphasis added). Webster's *New World Dictionary* defines the word *assay* as a testing, an analysis of the ingredients of an ore or drug, to have a specific proportion of something. I began to understand that there would be times when He would allow me to challenge areas of weakness or sin in others, but most of the time I was to "be still" and just "know" (Ps. 46:10).

This was a "new beginning" in an area that He wanted to be sure I understood. It would be one of the foundational truths and cornerstones of the ministry that He was preparing for me. I eventually removed my children from the Christian school where I was volunteering and home-schooled them. Suzanne was still having experiences in the spirit, but they had taken a different turn. One day, in my ignorance and immaturity, I called a large ministry whose founder had had some of the same experiences. Lacking an understanding of ministry protocol, I thought I could just pick up the phone and talk to the man of God. I hung up the phone when I was told a

counselor would be right with me.

Suzanne began to withdraw. It seemed as if fear had allowed other things to come in and make it hard for Jesus to continue to work in her life the way that He had been for the past several months. One day while at a home party, I got a call from her dad to come home. He said Suzanne had been attacked. When I arrived, Harris had already called the police. Suzanne's face was covered with dirt and the T-shirt she had on was torn. After a few moments with her alone, I realized that she had been attacked by the supernatural. I knew it and she knew it, but no one else was going to believe it! We spent several hours at the local police station over the next few weeks. They told me that Suzanne was a liar and that no one looked the way she had described her assailant: He was dressed in leather and spiked jewelry and had the word *murder* tattooed over his left eyebrow.

I knew Suzanne was telling the truth! For several weeks prior to the attack, the enemy would come to her in the night and tell her that he was going to kill her. After one such visitation, Suzanne and Zoë, just nine years old at the time, were almost hit by a car. When they told me what had happened, they both said they felt as if a large pillow had been placed between them and the front bumper of the car as it came to a screeching halt. The direction of these events began to put Suzanne in a downward spiral. I sought help from those in leadership positions at our church, but they were convinced that Suzanne was not telling the truth. Eventually there were no

more experiences—good or bad.

One day several months later, as Suzanne lay stretched across her bed, the Lord spoke to her. I still have her hand-written record of the event, on her stationery. It reads: "Why have you not trusted in Me? Do you not know that those that trust in Me are My precious ones and the ones with the abundant life? Sayeth the Lord."

The message was plain and simple. We had been graced with an experience that few Christians ever taste, yet it left as suddenly as it had come upon us. Perhaps God came because He knew we were desperate for a release from the pain we were experiencing at the time. Perhaps, had I been more seasoned in the Lord, I could have helped more. I don't know. What I do know is, after God confirmed these experiences for me, I never questioned them. I felt blessed that we had been allowed to have them. I felt honored and privileged that they came through a child He had entrusted to me for a season. I pray right now—and ask you to agree as you read this—that Suzanne will be reminded of the special season that she had with the Lord and fulfill His words to her as "minister to the world."

The children were now all in our church school. I had a weekly ladies fellowship in my home, was part of the prayer team and served as an altar worker. It was awesome what God was doing spiritually with the children and me. Even Harris had opportunity to be blessed. There was still great turmoil in the house, but the strength that the children and I were receiving

kept us on top. Tulsa is the last place that an unbeliever wants to be with a wife who is on fire for God. Our divided kingdoms still kept Harris and me somewhat separated.

When we had been in Tulsa for about eighteen months, Harris took a trip to central Florida, where his family lived and owned businesses. He felt that it was in our best interest to move there. I really wrestled with what God wanted. The children and I had settled in, and another move was...well, another move. Danielle had graduated and made her way to Florida to be with her dad, and rebellion was beginning to touch Suzanne's life. I cried out to God about the time and effort that had gone into these girls, and he spoke to me loudly and clearly: "Thus saith the LORD; Refrain thy voice from weeping, and thine eyes from tears: for thy work shall be rewarded, saith the LORD; and they shall come again from the land of the enemy" (Jer. 31:16). I still hold fast to this promise for all my children.

One of the problems with a move to Florida was the threat I felt in dealing with several unsaved family members. I continued to inquire of the Lord what His will might be. One day He led me to a scripture in Psalms. It read:

> Be ye not as the horse, or as the mule,
> which have no understanding: whose
> mouth must be held in with bit and bridle,
> lest they come near unto thee. Many sorrows shall be to the wicked: but he that
> trusteth in the LORD, mercy shall compass
> him about. Be glad in the LORD, and rejoice,

> ye righteous: and shout for joy, all ye that
> are upright in heart.
> PSALM 32:9–11

Although I didn't welcome the move, I felt it was what God wanted. By June of 1986, we were once again on the road to new places and new faces. I had learned many things in the short two years we were in Oklahoma. It was truly, as God had said, "a time of precious new beginnings"—a time that turned out to mean everything but what I thought it would. It was a new beginning in the Spirit. I had learned about knowing people by their fruits, how to put my desire to serve into action, and how to seek God and pray His Word.

Through months and months of early morning prayer meetings at the church, and then on my own, by the time we transitioned to Florida I had built a reservoir of prayer that I would be very thankful for in the months ahead. I prayed God's promises, not my problems. I was tight with God. My spirit was in tune. I obeyed the caution lights of the Holy Spirit. Things were still very difficult at times, but the richness that God was pouring out far exceeded the pain. I learned what it was to "enter into the fellowship of His suffering" (Phil. 3:10). I was my Beloved's, and He was mine! He was blessing me, and surely there was a "precious new beginning" to my love affair with Him. What I accumulated during those brief two years, I would draw on when we moved to Florida. I do not know how or what would have happened had I not been prepared spiritually for what the future held for my children and me.

Chapter 9

A Beginning As Well As an End

For I know the thoughts that I think toward you, saith the LORD, thoughts of peace, and not of evil, to give you an expected end.
—Jeremiah 29:11, emphasis added

Thank God that we can rest in the truth that God knows the beginning as well as the end to a thing. If He knows, then He has all the necessary provisions for the time in between.

I didn't know what would face us as a family once we arrived in Florida. The trip there was horrendous. I piled all the kids into our old Oldsmobile and drove it, towing our propane van. Somewhere in Tennessee, I rear-ended the truck and trailer that Harris was driving. Our very presence in Florida seemed to produce some concerns for Harris's family. The relatives who lived in the house next to the one we would rent, tried to sell their house before we got there—but God had other plans. (Thank God for a reservoir of prayer!) My kids, aside from their father (whom they understood to some degree), had never been exposed

to many unbelievers; now unbelieving neighbors and family members surrounded us.

But God had a plan. I began to walk the neighborhood very early each morning, most times in the dark. I did what I knew best to do, and used what I had learned from all those months of early morning prayer in Tulsa. Larry-Lee style, I pulled down strongholds and claimed the neighborhood for Jesus—especially my next-door neighbors. This was in September; by the time Christmas rolled around, Harris and I separated. This would be the first of the yearly separations we went through for the last seven years of our marriage. That first Christmas my relatives next door blessed me and my children with the best Christmas I personally had ever had. God was putting a spiritual hunger in them. It was not long before my sister-in-law came knocking at my door. One night, after we put fear to rest, she came to the Lord. A few weeks later her husband followed, and soon they were going to church. On Christmas day of the following year, they both stood arm in arm with their two teenage children and proclaimed Jesus.

I began to notice that other families were getting spiritually hungry. God delivered and restored one lady who had a sexual problem, and another family miraculously made it to the feet of Jesus. I was in awe of what was happening in the neighborhood; then one day God reminded me of the prayers that I had sown for many, many months in the wee hours of the morning as I walked and spoke life into the neighborhood. I was seeing the first fruits of prayers

prayed from the heart of God through a vessel that was learning to yield.

My marriage continued to deteriorate. The gap only broadens as time goes on in a relationship where the partners are unequally yoked. (See 2 Cor. 6:14, NKJV.) I have learned through the years that a person can be unequally yoked in a variety of ways. Unless individuals are totally surrendered to Christ and are committed to restoration of their relationship no matter what the cost, their different directions in life lead to different destinies and finally bring an end to the relationship. Eventually we outgrow our addiction to painful situations and relationships. Certainly my background had a great influence on my high tolerance for extreme emotional pain and what would seem, to some, to be unbearable circumstances.

The children and I settled into a good church where we remained for nine years. Although the kids were in Christian schools during this time, our home life continued to be chaotic. The wounds of alcoholism, along with my own anger and frustration, created emotionally unbearable situations for all involved. My prayer life was strong and kept me sane, but I didn't fully understand all the aspects of how we had lived and the consequences of what my children had endured.

By the time my marriage was irretrievably broken, the older girls were on their own. With my focus now on my three younger children, I began to acknowledge the emotional damage we had sustained over the years—although I probably didn't understand the full extent of it. The anger, frustration and emptiness

that I felt after a fifteen-year marriage ended in failure weighed heavily on me and strongly influenced the treatment of my children. I was a Christian, reaching out to the lost; I loved God and had a strong prayer life, yet I was verbally abusive to my children. They reacted.

Zoë, now in her teens, left home to live with a friend. Asher began to use drugs, and one day, at the end of my rope, I packed him up and shipped him to his dad's—a decision I would regret many times over in the coming years. It seemed as if all my hopes, dreams and expectations for my children would never come to pass. They were suffering all the by-products of an alcoholic father and a strictly religious mother. They had witnessed the extremes of two completely different lifestyles and belief systems. My children were called of God, musically talented and extremely sensitive to the Spirit, yet they were exposed to an environment of confusion and emotional lack. Once outside the home, each of them adopted a lifestyle that reflected their unmet needs. Loved, yes; cared for, yes; provided for, yes; but also confused, angry and left with a feeling of being shortchanged. They suffered greatly, not only because of their choices, but also because of their exposure to addiction and fanaticism. They had had experiences in the supernatural that most had not and, in their earlier years, had heard and acknowledged their call by yielding to God. Zoë began singing in church at the age of four, wrote music at age ten and was a self-taught pianist by age twelve. Asher could always draw

a crowd with a God-given charisma that grown men envied. He became interested in the Book of Revelation as a very young child, and read it with supernatural interest and creative insight—often offering his opinion of it, sparing no words. Jed was sweet, sensitive and anointed to play the drums. He has a tremendous compassion for people that is still surfacing to this day.

These were my angels, my precious ones; and now their lives were taking paths that I hoped they would never travel. My marriage was now over, and all my children except Jed were prematurely gone from home. My emotions were on overdrive, and my hopes and dreams were shattered. I was confused and lonesome, and switched into my survivor mode. God continued to speak and move. I buried myself in His Word and wrote several songs as well as a musical production called *The Crimson Trail*. Great things were happening, but my children were in pain.

Somewhere in the midst of all this, I lost the reality of my children's condition and pursued the call that I had felt since childhood. I was growing discontented with the church that I had attended for so long and raised my children in. I began to feel that I would not be used in the church because of my past, not realizing that my ministry was to the lost *outside* the church. Most of my ministry experiences up until this time were to those outside the norm of your basic churchgoer—or even your "normal" unbeliever. God put the worst of the worst in my path, and I would do as I felt Jesus would do: love them and lead them to Him.

About this time a revival hit a major church in our area and the meetings went on for weeks. This revival changed lives, leadership and whole churches in the central Florida area. It brought a freedom and liberty that the body of Christ had not known for many years. It touched me and made me hungry for God in a way that I had never known. I felt as if I was on the brink of many new things in my personal life and ministry. God had a plan, and for the first time I acknowledged in a very deep way the purpose to which I had been born. I felt very motivated in its pursuit.

Yet, Satan loomed in the shadows with a plan of his own.

In the third chapter of Luke we read how Jesus was baptized, given His Father's stamp of approval and set forth to do that which He was sent to the earth to accomplish. In chapter four, full of the Holy Ghost, Jesus enters the wilderness only to be tempted by Satan. He responded using the sword of the Spirit, the Word of His Heavenly Father, and overcame every obstacle and snare that the enemy sent His way.

In 1995, at the end of that glorious move of God—with all that had happened, all the revelation, all the liberty, and all of that which my heart contained, feeling so directed and so established and ready to fulfill what God had for me—I didn't fare so well. Satan tempted, and I was ensnared by a relationship that took me on a six-year detour away from God's plan for my life. Satan had sent his henchmen to entreat me with an assignment from hell!

Chapter 10

Perfect Will, Permissive Will or Perdition

And be not conformed to this world: but be ye transformed by the renewing of your mind, that ye may prove what is that good, and acceptable, and perfect, will of God.
—Romans 12:2, emphasis added

*P*erfect is defined in *Webster's New World Dictionary* as, "complete in all respects" and "flawless"; *permissive*, on the other hand, means "allowing freedom" and "lenient." *Perdition* means "the loss of one's soul."

Our soul is the seat of our emotions, passions and appetites. But it is also our mind, our will, our character, nobility and reputation. Matthew 10:28 warns us, "And fear not them which kill the body, but are not able to kill the soul: but rather fear him which is able to destroy both soul and body in hell." When we make choices and decisions in life that are led by the Spirit of God, we most often find ourselves in His perfect will and moving toward completeness in all respects. When we chose a path a little to the left of

His best, He sometimes allows some freedom and leniency. However, there are times when we totally disregard God's leading and the voice of the Spirit. At those times, we press way past God's perfect will, and even His permissive will, and move into the area that Matthew warns us about. We are on our way to perdition—to a hell that will influence and affect every area of our lives. Since God desires for us to be blessed, I'm sure He grieves when we choose to walk away from His perfect plan for us.

Who knows why Christians fail? Even with all the bells, whistles and caution lights from the Holy Spirit, we sometimes do that which we have criticized in others. We make our way through the muck and mire of disobedience with relentless justification of our actions.

In January of 1995—the week after my revival meeting experience—I was fifteen years into my salvation and, once and for all, determined to embrace the call and destiny that I have felt since I was a young Catholic girl who desired to become a nun. Like the woman with the issue of blood, many times through the years I had touched the hem of His garment for healing. Like the woman at the well, I had let God expose my sin, save me and ignite a passion in me for souls. And like the woman caught in adultery, God had delivered me from all my unclean dwelling places...or so I thought.

For years I had sat in the church and watched people fall into sexual sin and the Holy Spirit in me would grieve for them. I would question how they

could hurt God that way. Yet in a moment's time, it happened to me.

I met the man who would become my next husband in the church where the revival had taken place, one night a week after the revival was over. I had watched him usher during the last week of the revival. He was different; unusual. He had a presence that demanded attention. That night before church started, he approached me and asked if I had enjoyed the revival. From that moment the ride began, and six years later it ended as intensely as it had begun.

The attraction between us was mesmerizing and took hold of us from the very beginning. We had come from very similar experiences and immediately began to pour into each other all the defilement we had experienced since we were children. Emotionally abandoned and starved for affection as a result of my first marriage, I welcomed the in-your-face attention that Michael gave me. He was charming and very attentive. We talked in the church until very late that night and on the phone once we were home until the wee hours of the morning. The next day he prepared a picnic in a local park and picked me up at my job so we could have lunch together. I don't recall anyone ever having done that before. It was a bit awkward...definitely unusual and yet exciting. There was tremendous chemistry between us. Now I know that it was all those "familiar spirits" having a heyday with two people who had been prematurely sexually imprinted and trained for other peoples' pleasure.

During our childhood years, Michael and I, though

miles apart, were both being schooled in ways that would affect and defect us for many years to come. I liked him almost instantly and, even when the Holy Spirit began to set off alarms, I forged ahead. We were both in the middle of divorces, and our relationship definitely brought changes to our previous spouses' attitudes. The relationship escalated and, even though the warnings continued, I was on an emotional ride that my senses enjoyed. Michael woke up the sleeping parts of me. He ignited things that had lain dormant for years.

As the relationship progressed, the enemy began to reestablish a stronghold on turf that had been vacant for very a long time. He had plenty of space and, as the Holy Spirit began to lift from my life, he had no major interference. Michael and I were married in a mall in Knoxville, Tennessee, four months after we met. Michael became my lover, my friend, my big brother and my fellow Christian. He also ended up hurting me more deeply than anyone else ever had in my life.

I didn't understand a lot about my sexual addiction at that time. I had never had a real issue with lust; when I recognized it, I just turned and ran the other way. So, throughout our six-year marriage, I reasoned with myself continually that our relationship was ordained of God.

Within the first six months of our marriage, Asher was diagnosed with cancer and I was spending a lot of time at the hospital. In my absence, Michael began to communicate with his previous wife (number

seven, I was told at the time). That would be the first of four times in our marriage that Michael would cycle back to the familiar when he could no longer cope with the current situation. This pattern had been established long before we met, stemming from his childhood when he was shuffled from one abusive relative to the next and from one totally different environment to another.

When you are the victim of extreme sexual abuse for the first half of your life, your coping mechanisms wear thin. To survive, you begin to build a hidden reality on the inside. (This is a defense mechanism that most victims of sexual and other abuses can relate to.) This hidden reality, this foundation of deception, begins to form block by block. In your everyday life, you master the ability to function somewhat normally on the surface, while on the inside you answer to a very different reality. It is this reality that triggers deadly cycles of addiction and bondage to a world and lifestyles that are both devastating and destructive in the deepest sense of the word. When your emotions have been in overdrive as a result of extreme sexual abuse since childhood, somehow, someway and at sometime, it begins to affect your relationships and poisons every area of your life. It is only through the redeeming blood of Jesus and our own sincere willingness that God can begin to bring healing. The process can take years.

Michael was one of the most giving, caring men that I had ever met—yet he was not what he appeared to be. Satan had a piece of him on the inside that was

bigger than his outside reality. Although he knew the Word of God better than most and was an able minister, in reality his spiritual life was all in his head and had never trickled into his heart long enough to stand against the onslaughts of the enemy. Each time his addiction beckoned, he ultimately chose to follow—no matter what the cost to himself and the relationships he was involved in. His relationships encompassed a large circle of friends and associates as well as his family, and ministries where he had regained credibility in the past.

Meanwhile, my own addiction and bondage held me captive in a relationship that was never God's will. I lived with Michael for six years in between his "cycles," but I also lived with a deep, daily grief and questioning on the inside. When I met Michael, I was on the verge of many things. I had a great job, a car, a home and money in the bank. God was giving me a platform for ministry—I knew it...and I felt it! Yet, my old addictions and unresolved issues caused me to cling to a false reality. I constantly justified my relationship with Michael. I had seen God many times take disobedient situations between couples, breathe on them and make everything wonderful. I hoped He would do that for Michael and me. But, this was not His choice for us.

Things worsened. One day in August of 1998, Michael left for an appointment and never returned. I totally lost it! In my heart I knew that he had returned to familiar patterns of behavior, at least until he realized that another relationship would not meet

his needs or fulfill his addiction. Many times mentors and friends told me that his life was one vicious circle, yet the unhealthy areas of my own life screamed in pain and reasoned reality away. My love for Michael was genuine; he had validated me in many areas that no one else had through the years. Our Italian backgrounds, history of sexual exploitation and the child in both of us that never got to grow up, made us kindred spirits. I was blinded by my own unrestrained appetites and, regardless of the continued warnings of daily situations and circumstances, I pushed passed boundaries that I had known, observed and adhered to for many years. I blatantly disobeyed God and ignored the voice of the Holy Spirit. As a result, I paid a very high price. The good news of the gospel is free, although it costs to convey; Sin, on the other hand, will cost you beyond what you can imagine. There is only one equation for sin: it equals much pain and much grief.

Michael's third cycle away devastated me. My employer put me on workmen's compensation and sent me to a psychiatrist where I was given antidepressants and tranquilizers. I don't know what my son, Jed (then thirteen), ate for those first several weeks after Michael left; I just know that one day I got up off the couch and the shorts that I was wearing fell to my ankles. The next day I decided I could not go on. As I sat in the condo we had purchased, surrounded by new furniture in rooms that we had wallpapered together, I was overcome by the deepest grief I had ever experienced. Even though on the surface I

had played the game, deep on the inside I knew that the deaf ear that I had turned to the Holy Spirit—and many, many others that God had put in my life—had brought me to this point. I was eating the bitter, painful fruit of my own choices and yielding a crop that God had never intended me to harvest. Taking my life seemed like the only option, and I had enough pills to do it, stored in a metal box that was hidden in my bedroom.

As I sat on my living room couch, I wondered what would be done with all my furniture and the many keepsakes that I accumulated for well over twenty years. Suddenly this thought came to me: *Let it all go!* Almost simultaneously I remembered a woman whose ministry I had experienced in 1995 when Michael and I attended a leadership gathering. This woman's ministry facility was called "The Secret Place." The second time that Michael left me, he had stayed there for four months to do some soul searching. When he came back, we felt that we were to commit to a year of service and prepare for ministry. (At the time, this was not feasible because of problems we were having with my son.) So, here I was again, eighteen months later, in the same situation.

That following week I attended a women-in-ministry meeting at The Secret Place. I never spoke to Pastor Shirley, but at one point she turned around and smiled at me in a way that said, "I know your pain." When I returned home, the Lord prompted me to write her a letter. I shared my heart and expressed my need and desire to fulfill the commitment that

Michael and I had previously made; only this time, I explained, it was just me, alone, and with a very broken heart. By November of that year I moved into The Secret Place to serve God, seek His face and heal.

Chapter 11

Purity, Purging and Empowerment

But ye shall receive power, *after that the Holy Ghost is come upon you: and ye shall be witnesses unto me both in Jerusalem, and in all Judaea, and in Samaria, and unto the uttermost part of the earth.*
—Acts 1:8, emphasis added

*J*ust before my transition to The Secret Place, I had a dream that I was walking a fence line with the Holy Spirit and we were sowing what appeared to be some kind of seed or bean. There were people in the background, and it was clear to me in the dream that I was not to make known among the people what we were doing. In the next scene, I was in a room in a house, and I was very aware of the presence of the Holy Spirit. The phone rang and someone answered it. There was someone with a need on the other end. I felt a strong desire to help, but it was not my turn. Next (whether awake or asleep, I am not sure), I found myself face-to-face with a pair of the most beautiful blue eyes I have ever seen. They were full of love for

me—soft, loving eyes that reached to the very depths of my being. They seemed to say everything to me, yet I heard nothing. These eyes knew everything about me, and they conveyed a love that no human could ever parallel. I was overwhelmed by the love that I felt coming from those eyes and the boundless love that I felt for Him—for they were the eyes of Jesus. I will never forget how full of love they were for me; nor can I ever forget the love that I felt for Him. I would reflect back on this experience many times during my year at The Secret Place.

I had worked in areas of administration so, when I went to work for the ministry, I was given the responsibility for the purchasing, planning and preparation of food for conferences and events. I loved being there. I dove in with both feet and felt blessed to be serving the many leaders in the body of Christ who came there. The heart of the kitchen became my home and, like most visionaries, everything was mine: the cooler, the freezer, and so on. There was a racquetball court on one end of the 44,000-square-foot mini-mansion-turned-ministry, where I spent many hours lending myself to the dance, crying out to God and finding communion and fulfillment in time spent with Him. Many, many times I surrendered myself to Him that His will would be done. I released my marriage to Him, even though the pain and grief was almost unbearable at times.

One night shortly after coming to The Secret Place, I had another dream. In this dream I was in a room when someone walked in with a huge bouquet—so

large that the person carrying it could hardly manage to get their arms around it. Each of the different colored groupings of flowers in the bouquet was wrapped separately, and a large card hung from it. I remember thinking with excitement, "My husband has sent me flowers!" When I looked at the card, I saw that it read, "I love you." The person carrying the bouquet then motioned upward and said, "From Him." Then the Holy Spirit spoke these words: "I'm going to make a bouquet out of your life."

God was beginning to reveal His will to me. My intimacy and dependency was to be with and for Him, not my husband. I had chosen to give all to someone who the Lord knew in advance would not handle it correctly. He had tried to protect and warn me, but I refused to listen and, as a result, paid a very, very, high price—my relationship with my heavenly Father, my commitment to His Son, and the comfort and guidance of the Holy Spirit.

It was January 1999; Pastor Shirley was having her annual Women's Invitational. Women leaders from around the world had gathered for a time of insight, refreshing and "revelational volleyball" (our tongue-in-cheek term for when the women share revelations back and forth). It was a privilege to be a part of this awesome event.

I had done my morning meal preparations and was in the racquetball court dancing with the Lord, when Pastor Shirley came in and said, "Michael is on the phone; are you ready to speak to him?" There he was again, interrupting my intimacy with God. "This is

prophetic," Pastor Shirley said. I paid little attention to the profoundness of what she had said. Aside from a ten-minute conversation in a parking lot, it had been five months since I had seen or heard from Michael. I had given myself over to the fact that I had married out of the will of God and, even though my emotions had not caught up, deep in my spirit I believed it was so. Yet, with my emotions in full gear, I took the call.

Michael was at the end of another cycle and was, once again, seeking higher ground. I told him that he must commit to God and a program to get help, or he would never be able to commit to our marriage. The next day he went into a program where he remained for fifteen months. In the meantime, I had four more dreams and each one seemed to scream, "No, no, no," with full explanation as to why. Still, I plunged ahead, justifying my every move.

One Sunday morning while I was preparing to visit Michael, the Lord spoke the word *apostasy* to me while I was in the shower. I didn't know what the word meant, but I felt as if it was a rebuke. I went back to my room and looked up the word in the dictionary. Then I heard the Lord say, "Why have you abandoned what you once believed?" As I had done with Pastor Shirley's comment in the racquetball court, I disregarded God's word to me. Like a spiritual Scarlet O'Hara, I moved ahead with an "I'll-worry-about-that-tomorrow" attitude. Once again I had not heeded the voice of the Master. Once again I was setting my own course, charting my own waters and heading for shipwreck.

My self-justification continued, but so did my unstable emotions and the relentless feeling deep in my gut that this was not what God wanted. I could blame my actions on my independence, birthed out of survival techniques spawned at a very young age, or my life-long disregard for authority, or just plain rebellion...but it didn't matter what I called it. I was simply out of the will of God! I'm sure that many who were close to me at this time knew it. But God has given us free will, and I'm sure that those I looked to at the time for guidance and healthy boundaries, felt they had to pray and allow me to follow my course.

Prior to Michael's phone call, I was beginning to understand my own addiction, though in a very surface way. I remember one day being in the kitchen with Pastor Shirley and realizing how violated I had been at such a young and tender age. Anger began to rise up in me as I said, "I was only thirteen years old. How dare they!" Yet my lifelong search and hunger for love caused me to continue to seek and receive love that in no way measured up to what God had in mind for me. My expectations were far below God's standards and desire for me. It was like being shipwrecked and grabbing hold of an old splintered board to keep you afloat; with each wave, the splinters from the board dig into your skin and cause pain. And all the while, just behind you, Jesus is standing at the bow of a rescue boat, waiting to throw you a lifeline.

I continued on this course for the next fifteen months. Michael and I renewed our vows a few months after he came home, but God's breath was

not on it. I continued to hold on to what was painful. What I once thought was His perfect will had now become, in my self-pleasing mind, His permissive will. Once again it became harder and harder to hear God. My relationship with Him became more functional than relational. My spirit grieved as I continued to pursue some type of superficial contentment in my everyday life.

Six months prior to Michael's coming home, I had taken a small house close to The Secret Place in an effort to reunite with my children and work on our relationships. My transition from The Secret Place was very difficult, as I moved from a loving, secure and protected environment back out on my own. But I knew that it was time to establish a nucleus where my children and I could begin to rebuild places that had been laid waste. Just before I moved, the Spirit of the Lord woke me several times one night, saying, "Mother's Wings, Mother's Wings." I got out of bed and went to my laptop. The following was what the Holy Spirit and I wrote:

Mother's Wings

I heard the rustling of Mother's Wings today. Soon I would feel the gentle prompting of her talons as they urged me closer and closer to the edge of the nest. Hesitantly I responded to her continued nudging. Reluctantly I maneuvered myself in response, not wanting to leave.

The nest was warm and well lined with feathers, which she had plucked from her own breast in preparation months prior to my arrival. I had been this way many times before over the past several months. Each time she would encourage me past the cavity of the nest. There I would stand faltering and suddenly with one swift movement over the side I would go. At first in a tail spin and then getting my bearings enough until she would finally swoop down and rescue me once again bringing me back to safety.

So why was this day to be any different? I heard the rustling of Mother's Wings as usual and rested in a trust that had been developed over the past several months. Why would this time be any different? The difference was not so much in the rustling of Mother's Wings as a difference that had emerged in me. A desire for change had begun to work it's way into my daily routine, and there was a noticeable change in the atmosphere as if something was about to transition from what it was to what it must become. The one that I had looked to for approval was now rejecting that part of me that must go on to something greater. The stirring of the nest and the now incessant rustling of Mother's Wings was rooted and grounded in wisdom. A wisdom that was

coming down from something much higher than our nest as it rested at the top of a pine tree that was nestled on the high mountain peak. Recently, I had heard a voice on the inside of me that grew stronger and stronger each day. Was this the same voice bringing clarity and direction to me that Mother's Wings were responding to? Still I struggled with difficulty as my mind began to consider the path ahead. Fear began to poke its tormenting head in as I considered this option and that option, yet buried within me there arose an overwhelming desire to pray.

As many times in the recent past, I responded to the once-again gentle maneuverings of Mother's Wings. Unknowingly, over the past few months everything I had experienced was preparation for this day. Reluctantly yet effortlessly I prepared myself for the edge of the nest knowing this time it would be different. I was well acquainted with every movement; every response had become an earned trust. Suddenly, as in times past I began my descent—only this time my tailspin was shortened, not by the rescuing reassurance of Mother's Wings, but by a trust in my own ability. I began to recall the movement of Mother's Wings and all at once that which she had used to bring me to safety in times past

> had become a part of me. The same ability she taught me by her example was now built in on the inside of me. I needed what she had given me, but I didn't need Mother's Wings in the way I had before. I had my own!

It was a transitional epitaph. I moved into the little house and God began to bring my children back, one by one. Jed, who had lived with his dad for the year I was at the Secret Place, got into some trouble and was court-ordered to a program for boys for ten months. His life appeared to be leveling off (or at least his choices had narrowed due to his situation). Zoë was in crisis. My heart broke for all the pain that she was going through, yet most of it was due to her own choices. I began to see myself mirrored in her life. The difference was that she had opportunity, because of her exposure as a child, to follow God, and she was still called and anointed by Him to sing. Asher was now supporting a full-blown addiction to alcohol and drugs. He, too, broke my heart. I watched my once-anointed child, chosen by God, spiral further and further downward. Many times I blamed myself particularly for his problems.

I enjoyed having the children around me again, even if it was very hectic at times. I felt as if I needed to persevere, to love them and to try to make sense of all this. There seems to be a fine line between helping and enabling. Our good intentions are sometimes motivated by guilt over past situations that we could not possibly make up for, yet we try endlessly to

resurrect the good—all the while realizing that what was hell for a parent, was inevitably hell for the children, too. We all continued to bear the scars both from my first marriage and from my current marriage to Michael. My children didn't trust Michael before his problems manifested themselves, and they certainly didn't after. Zoë tried the hardest to have a relationship with him—and they really appeared to enjoy each other's antics at times—but time was the truth serum. In the end, most of what they felt was not far from the hidden reality that ruled Michael's life.

About this time Michael and I took an opportunity to spend four months in training and continued healing under a women who had a facility for recovering addicts. Michael sat in most of the sessions, while I spent my days trying to raise money for various projects. Barbara was an ordained minister with twenty years of experience in addiction counseling. Within minutes she could peel a person like an onion and get to the root of their problem. I admired her ability and keen insight. Three years before we were there, armed with a government grant under a local coalition, she had taken over a city street that was once occupied by some of the most notorious drug dealers on the eastern coast of Florida. One by one she populated the sixteen apartments on the street with recovering addicts of all kinds. We lived among these people during the week and returned home each weekend. I love these people and Jed seemed to settle in. But it was Michael who particularly seemed

to relax in this environment. He enjoyed his sessions with Barbara and once said that he had gotten more out of the four months that he spent there than the fifteen months he spent in the other program. Pressure began to build when the coalition that held the strings of the government grant began to make demands that a woman of God could not possibly comply with. We left one month short of our initial commitment and Barbara resigned within a month or so of our departure.

We returned home and took a larger house around the corner from where we had been living. Zoë and her son, Christian, now 5, moved into a little house near us after a very painful ending to a three-year relationship that was destined for destruction from the beginning.

Once we settled into our new home, Michael began to move back into areas of ministry that he had previously been involved in. But I know we both felt an underlying current of discontentment—Michael, because of his addiction and me because of a deep grieving in my spirit that was now an accepted part of my existence. I had a deep, genuine love for Michael and enjoyed the healthy parts of our life together, but my inner grief—now calloused from being overlooked and justified so many times—seemed like the "club foot" of my spirit. I simply got used to the limp. My unfulfilled desire to be loved somehow overpowered the exchange that I had experienced many times over and over as I danced, laughed and cried out to my God in the racquetball

court while at The Secret Place. Once again I had settled for the splintery board of a relationship that would not hold together in hard times. The foundation was not built upon God, but on familiar spirits, years of unmet needs and false concepts.

As with the change of the tide, Michael once again turned away. He left one Thursday morning to run a few errands and only came back to get his belongings. We exchanged a few words—enough to let me know there was another woman. How consistent the enemy was at showing up in his life! And how willingly Michael stretched his neck time after time across the chopping block of sin.

I tried wholeheartedly not to respond in the way that I had in the past, but the shock of this was numbing. Had I not cried enough tears? Had I not felt enough grief? Again the wheel had come around. Michael was chasing his addiction, and I was reaping the bitter fruit of my own disobedience. I guess I thought God would forget, that He would look down and say, "OK, Donna...if you insist." Since I was determined from the beginning to have this relationship, God allowed it; but that didn't exempt me from reaping the consequences of my disobedience.

Let me say this to you: SIN IS VERY, VERY PAINFUL! Only those who have tasted the pain and grief of disobedience to a very loving God know what I am saying. Believe me when I say, if you are reading this book right now and God has been dealing with you over and over about an issue or relationship...LISTEN!

Over the next few days I began to think about the pain that my marriage to Michael had caused his previous wife. Now armed with a better understanding of addiction and the devastation it brings, my thoughts turned with much compassion to this woman. I had thought of her many times over the years and always felt like I had hurt her more than I had ever hurt anyone else in my Christian life. I felt it necessary to write her a note to ask for her forgiveness, that we might both be released into our destiny—and I did. I truly felt it was what the Lord was requiring of me in order to bring closure to a very difficult situation. If you have spent the majority of your life pleasing and helping others—even when it is based on the misuse of a gift of compassion and longsuffering—it is heartbreaking and very troubling to know that you have hurt someone so deeply.

This is where I have to tell you that these last few chapters are being written while this is all very fresh in me. I am writing this particular chapter only two months after my husband left. But God has been gracious. I could not possibly tell you all the ways that He has come through for me. Even through the heartache and the pain, I have come to understand, in a much deeper sense, that "without holiness, no man will see God" (Heb. 12:14). He is calling not just me, but all of us, to holiness. He is a jealous God and He wants *all we have* to be submitted to *all He is*. The chastening of the Lord is not pleasant, but in time it brings about the fruit that the Master desires us to have in our lives. Don't fool yourself any longer. If you are

called of God and desire to serve Him in this great end time move, make no mistake: HE WILL PURGE YOU! He will separate you from any entanglements that will hinder your effectiveness and distract you from total absorption in Him. Some of this separation will be easy and some will come with much pain and difficulty, depending on your obedience. WE MUST OBEY THE VOICE OF THE SPIRIT! Our empowerment *by* Him is in direct proportion to our obedience *to* Him! His purging will bring forth the purity that is required to fuel His empowerment that is necessary to fulfill our destiny and call.

Chapter 12

Journey Into Wholeness

But Jesus turned him about, and when he saw her, he said, Daughter, be of good comfort; thy faith hath made thee whole. And the woman was made whole from that hour.

—Matthew 9:22

"You have a lot of resentment," she said. "Not from your second marriage...or even your first one. It started long before that, when you were very young."

My insides began to churn; a deep churning, the kind that I have resisted for most of my life.

"There is a very deep place in you that shelters a very hurt, rejected and abandoned little girl," she continued.

Something was happening on the inside of me. "I don't want to go there," I said. "I can't even think about going there."

"We will," she responded. "We will go together, and I promise not to take you somewhere inside that you can not return from."

I questioned myself as she continued to speak: *What's happening to me? Why am I feeling so much fear,*

so much pain? I don't want to go there. Just the thought of going back to my childhood and having to deal with things that were so buried, so guarded all my life, made me feel weak and exhausted.

Again she reassured me, "I will not take you where you cannot return from. That is your fear is it not?"

I nodded. "I can't even begin to go there."

"Well," she said, "we will go together and it will be OK, I promise."

I nodded again in weak surrender. The whole scenario left me totally exhausted for the rest of the day, but I knew that there would not be any further progression toward wholeness for me if I didn't submit to this process. My life would change; everything would change and be affected by my surrender. This was an unexpected stop in my journey toward wholeness, but stop I must. I had responded to numerous altar calls, I had prayed in earnest for years, and others had prayed for me; but this was going to be different. God was working at the very core of my being. He was touching areas that had to be healed and cleansed from the hurt, devastation and trauma of the past.

A few days later I went back to bed one morning. This was unusual for me. Somewhere between sleep and semi-consciousness, I had a flashback. I was sitting on the floor, face-to-face with this woman and that feeling came back stronger than it had been in her office just a few days ago. I began to say, "Oh, my God! Oh, my God!" As I did, I saw myself as a very small child—only several months old. I was sitting on what appeared to be a kitchen floor with black and

white squares. In the background I could hear my dad's frustration and anger. The flashback ended as quickly as it had begun. Next I found myself as an adult. An unseen person, who I believe to be the Holy Spirit, was walking very close to me; His arm was intertwined with mine. I began to grieve very deeply for a friend who had recently died. Although I had mourned for this person, I had never had as deep a release as I was feeling as I walked alongside the Holy Spirit.

Although these two experiences remain very fresh in my mind as I write, my mind is boggled and I do not have the full revelation of the meaning of either one.

I was beginning to feel like an old can that was being pried opened. Although for years the can sat on the shelf looking OK, deep inside its contents were rotting day-by-day, year-by-year. There was also a deep-seated resistance way down on the inside of me toward anyone who attempted to unveil those hidden parts. But this time the work was that of the Holy Spirit, and I knew it was the time and season for all to be shaken that could be shaken. I didn't know where this would lead in the seasons to come, but I was sure of one thing: It would lead to God in a more magnificent way than I had ever experienced before.

God had led me to a place of total exposure. It was a place of recovery; a place where my hindrances could no longer be hidden; a place of total surrender to the process. So here I was, on the chopping block of life...a little off here, a little off there. My twenty-plus years as a Christian had brought me to another

Red Sea and, of course, another Moses. I was once again facing Goliath. God had drawn a plumb line, and I was given another divine opportunity for pruning prior to producing. Some plant, some water, but God gives the increase. Well, some are pruned, but some are *really* pruned! The pruning process determines the yield, and the degree of our surrender measures the degree to which we will flourish in our field of ministry. Since God has called me to a ministry to the broken, it was through brokenness that I must come.

Can we possibly find comfort in the fact that what God does *to* us is inevitably tremendously useful as He works it *through* us to touch and change the lives of others? Is that not our commission? Is it not the very desire of your heart to become "helping hands for hurting people"? Can any of us facing the pain and grief of broken promises and unfulfilled dreams—right now, at this very moment—dare to believe and trust that someday, somehow, what the enemy intended to use to destroy our lives, families and ministries, can and will be used for His glory? I say yes; we can and we will!

Recently I spent a week at a center for prophetic counseling. It was totally ordained by God; and timely, due to my situation. The night before I left, I had a dream. In the dream it was dark, and I was ministering to someone in my usual manner. The person was sitting down and, as I touched her, I noticed a bag of flesh that hung off her right side. I continued to minister to her as we walked down what seemed to

be an underground corridor, like the catacombs of an ancient city. Because of some of the responses that I was getting, I asked God, "Who is this?" When she turned, her face was partially distorted. Next, I was in a square room by myself. The room was made out of the same material as the corridor. I stood against the wall and, across the room in front of me, I could see a stairway leading up and out. I began screaming, "No, Jesus!" In the background I could hear something that sounded like the nails being banged into the cross. I then screamed, "Yes, God. Yes!" Then I woke up. I didn't realize at the time that the dream was a prophetic interpretation of the week that I would spend at the counseling center. My flesh was about to be crucified and my first response was NO! However, I finally did yield to the process in the end.

This dream really paints a vivid picture of our journey into wholeness. We are crucified with Christ. We must die to our flesh in all areas. Some of us need more dying than others; some of us sport bags of flesh because of the exposure we have had to certain environments and the imprinting of our lives that results from those experiences. But this truth remains: When we die to our flesh, when those areas of our lives are taken to Calvary, what remains and what is resurrected is a vessel that can truly be used by the Master. We die so He can live bigger in us! What a deal!

Although it has come by way of much emotional pain and personal suffering, never more in my life have I been so aware and submitted to this process. It

is a journey. I believe true ministry is birthed when our attacks cease to come from the junk that has stockpiled on the inside of us through the years. As children of God, called and answering to a higher expectation, we will always have trails, tests and pressures. The Bible does tell us, "Woe, to whom they come from," but I am finding myself more and more appreciative of this process as time goes on. Although unpleasant, the end result is one of hope and promise. God is so good and so faithful. He stands by us always, arms folded, waiting patiently for us to propel Him into action by asking, seeking and knocking (Matt. 7:7-8). Our faith pleases Him and moves the Holy Spirit to act on our behalf. The Word of God in our mouths moves mountains out of our lives, creating the ultimate fulfillment of promises from a loving, caring God.

The process continues. It seems as though we leave one Egypt only to pass through another Red Sea, led by another Moses, through the grace of God to again be confronted by another. It is the constant slaying of the Egyptian in us. All this has brought me to one resolve: Without Him I am nothing. It is a personal and at times lonesome journey back to wholeness, although not one without tremendous rewards. Each stripping and each act of obedience seems to propel and usher in an open heaven of blessing.

Many years ago I had a vision in the spirit while praying. I was standing outside a huge gold door that was slightly ajar, and my body was covered with what appeared to be Spanish moss—the kind you see

hanging off trees, camouflaging their beautiful leaves and keeping the sunlight from getting to them. Point taken? My spirit was outside my body beckoning me to come in. I felt as if the Lord was saying that if I would allow Him to remove the dross from my life, then I could enter into this golden door.

This process continues today in my life. As I am writing this last chapter, my journey toward wholeness continues. Do I feel as if I have come a long way? Yes; but I know that there is much more to say, much more to do, much more that I do not see. My heart is changed, my mind renewed and my spirit more yielded to the process.

There has been no other intention in writing this book than to obey the word given to me to get it all out and write it down. In this I have fulfilled my commission. If it has touched one heart, dried one tear or opened just one person's spirit to the reality of Christ, then my efforts have not been in vain. I once heard someone say, "What we do not confront, controls us." I have written my story not to exploit myself, but rather to expose the defeated work of the enemy in a life that has been truly touched, changed and blessed by God. I do not have all the answers, but I know who does, and that makes all the difference in my future.

I have made some very bad choices and decisions in my past and have eaten the fruit of them all, only to find a loving, forgiving God on the other side of my disobedience. Once again I have come through

and have hit the pavement running—this time more determined, more focused and certainly more yielded to His plan and purpose for my life. He is number one. I have shed the weight of much of that dross depicted in the vision He gave me, and I have begun to see just a glimpse of what is on the other side of that gold door. My compassion for the lost has deepened, and I have received a mandate from God to "Go!" My spirit is at peace and my emotions are in check. I have outgrown the need to suffer that was spawned by my early exposure to the dark places of this world. Today I stand knowing that, all along the road I chose, God had a plan and a purpose for my life. I have grown up and taken the responsibility to pursue it.

I thank God that I have had the support of loving, caring pastors, as well as the wonderful body of believers that I have come to know and love at Tree of Life Church, from whose hand His provision has come many times. Cycles have been broken and healthy boundaries set in place through the oversight, encouragement and mentoring of people who care.

The Lord spoke to me last year and said, "The church *will not change* the harvest, the harvest *will change the church*." I didn't hear it from someone else or read it; He spoke it directly into my spirit as I was working at my computer. I thought at the time, and still do think, that this was quite profound. Today testimonies like my own are not uncommon in many churches across America (especially inner-city churches); many in ministry today have come from lifestyles that are even

more extreme than my own. Hold on to your hat; we are coming to the front! For many, many years I sat in good churches, under the teaching of great men of God, intimidated about my past and unable (except on rare occasion and with much coaxing from the Holy Spirit) to share my testimony. My efforts were crippled in the ministry that I felt so strongly called to. I feared, because of my past, that I could never serve in a church body, though all the while I was having God-encounters of ministry outside the church.

Let me say this right here: No matter how much of the Word and great teaching you have, unless it can flow through a changed life that has been touched with the infirmities of this world, you are just rehearsing the lines of someone else's life without a heart-connection to the experience of Jesus Christ. A heart yielded in total submission to God allows Him to do *to us* that which empowers the Holy Spirit to do His work *through us* in order that we might fulfill our commission, answer the call and prosper in our God-given vision.

Several days ago I went to help a friend unveil some eighty rose bushes on her property. A very fast-growing vine had covered the more than forty different varieties of the most exquisite rose bushes I have ever seen. Many of the rose bushes were more than twenty years old. Under the weight of this smothering vine, they were stooped over and several of the supporting branches had broken off. We labored the better part of the morning to loose these beauties from their strongholds. In the process, we had to cut

away a few branches that were so intricately intertwined with the vine that you could not unravel them from their killer. Most, however, were freed to once again extend upward and draw sustenance from the sun, their life source. As we cleared around the base of the roses by pulling out the vines at the root, the bushes were once more free to drink of the water that sustained their life.

What am I saying? What is God saying? Is the beautiful life that God has given you veiled in the dross of sin, or shrouded by the weight of bondage and addiction in any area? Are you crouching over due to choices, circumstances and decisions made outside the will of God? He *can* and *will* free you! He can sever your life from the heavy vines of your heritage, your past and even your current choices! He can uproot the things that daily occupy places where He wants to rule and reign! He is God!

I invite you to consider your life. Does it fall short of your expectations and the commission God has placed deep down inside you? He can and will free you to lift up the hands that hang down and receive from the source of all life, Jesus Christ. He will cause you to drink the living waters of His truth and Spirit that will cause you to never thirst again.

Today I understand that, although I am called and part of a local church body, my commission and assignment for the most part is outside the four walls of the church. As we allow God to destroy the roots of our past and clean out the vines of sin that have tried to smother us, He in turn will begin to use this

newfound freedom in our lives as a vehicle to touch and change others. He will set you in places and before people for whom you will have a compassion and drawing. He will use those areas that were once broken places in your life as a catalyst for change in others. God is very resourceful and not wasteful. That is why He knows the tears we have shed and the number of hairs on our heads. He is a God of detail.

As you journey toward wholeness in your life, your vision will become crystal clear and your quest to fulfill the call that He placed on the inside of you will stir you in a new way. It is His touch of refreshing that will add new dimensions to the old waste places of your life. Your empty cisterns will be filled anew with the fresh, clear, living water of His purpose, and the altars that you have built along the way through pain and sacrifice will give direction and insight to those who follow. It is a journey; it is His journey on the inside of us. Jesus is trying to find His way in us and through us. He wants to get out through you to touch a lost and dying world with His resurrection power. God is a God of the now! So get up, shake the dust off your feet and let's go! The journey continues. Bon Voyage!

If you want to know Jesus as your personal Lord and Savior, you can ask Him in a simple prayer:

> *"Father, I come to You in the name of Jesus. I believe in my heart and confess with my mouth that Jesus is the Son of God, that He died for my sins and rose from the dead. Jesus, I commit my life to You this day. I ask You to fill me with Your precious Holy Spirit. I thank You, Father, that my life is now brand new in You."*

Date: _____

Signed: _____

God Bless You!

Dear Friends:

It is July of 2002, and more than a year has passed since I completed this manuscript. I have healed, taken a missions trip to Mozambique, and I am in the process of opening a home called "The Red Tent" for the healing and restoration of women. God is awesome and wonderful as He moves us from tragedy to triumph. I hope that you have found something within these pages. Maybe you found yourself; hopefully you found God. My prayer is that this book has conveyed the truth and blessing of a life eventually surrendered to God. God wants every part of us, even the hidden places of our hearts. Some of us have held this pain for a lifetime. Only when He holds our hearts, will our lives be visited with the fullness of all that He has. I challenge you, whatever it is; He *can* and *will* make it OK. Allow Him to take the waste places of your life and bring new life to them. He is the Big Daddy of them all and He is coming back very soon. Until He does, I'll be...

In the field,

Donna